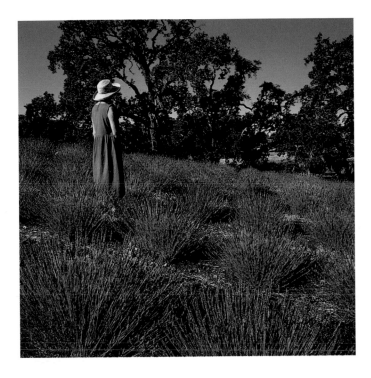

for susan

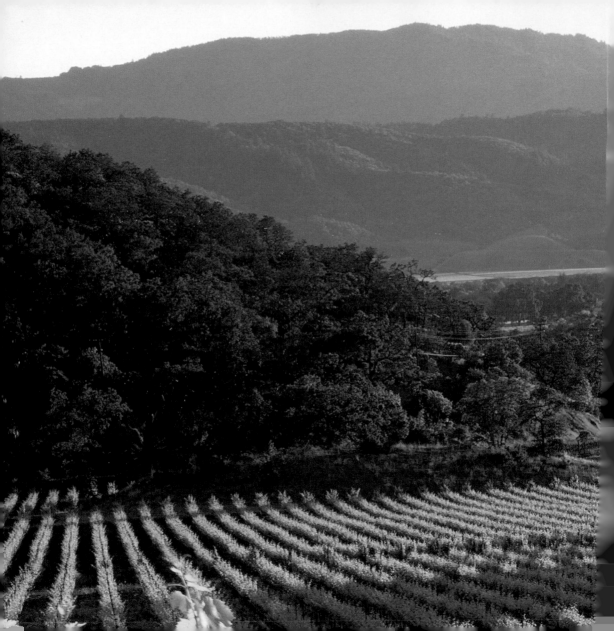

HIDDEN
NAPA VALLEY

PHOTOGRAPHS BY WES WALKER
EDITED BY PETER BEREN

Welcome
BOOKS

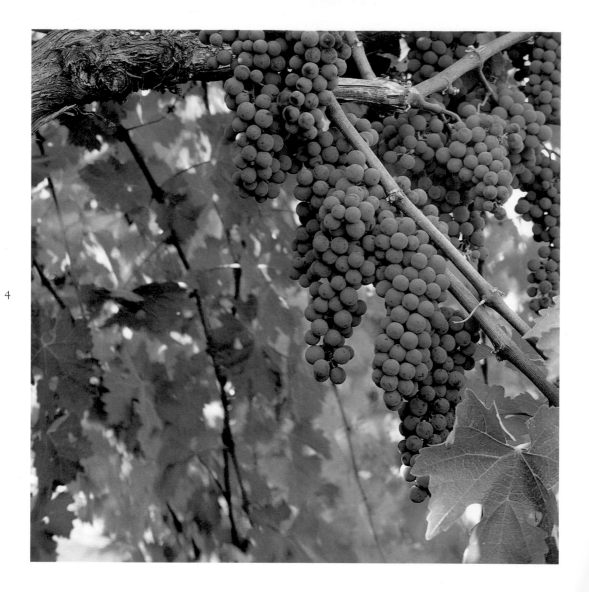

Each season in the Napa Valley stands alone in its extravagance and meets the eye with a brilliant abundance. Fields of wild poppies and mustard burst forth in early spring, followed by acres of vineyards breaking bud. Summer's longer, hotter days turn vineyards, heavy with fruit, a lush green against hills of drying grasses. After harvest, as the days cool and shorten, the eye is met with vibrant golds and vermillion against clear blue skies. Then, an elegant return to the bare architecture of life in winter—gnarled vines, organic earth, rain-filled skies. Yet, the hidden beauty I care about most comes from a deeper source, which sees the valley's rarity as a place in which people and nature flourish. Thanks to the sheer tenacity and foresight of those who preceded us—who were devoted to grape growing, the crafting of fine wines and the preservation of its history—the Napa Valley's beauty is a living testament to the value of keeping landscapes open against urban sprawl. It is my hope that the images I've captured here will not only document but inspire each of us to conserve and protect such beauty for ourselves, and for all who follow. Enjoy!

WES WALKER

Shafer Vineyards at Stag's Leap looking west toward Yountville and the Mayacamas Mountains on the western side of the valley. (preceding spread)

Cabernet Sauvignon grapes, just before harvest, on the Walker/Pacey Ranch. (opposite)

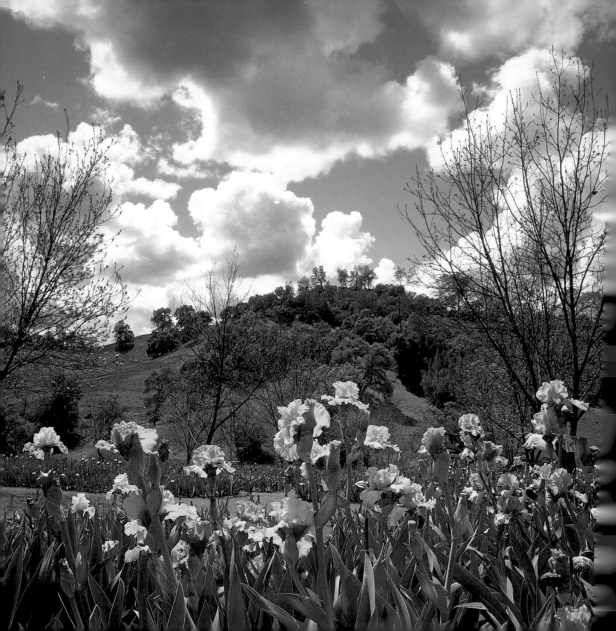

SPRING

WHEN the mustard grass is in bloom, Napa is perhaps the most beautiful place in California.

Roger Rapoport, travel writer

Napa Valley Iris Farm. Located in Steele Canyon near Lake Berryessa. (preceding spread)

Late winter mustard in a vineyard by the Artesa Winery pond. Artesa Winery used to be known as Codorniu Winery. Its Spanish-owned winery is an architectural marvel, built into an existing hill.

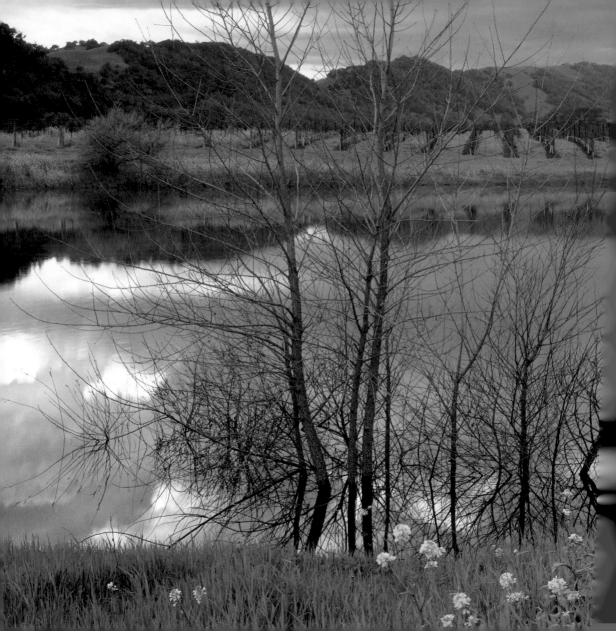

A glorious time! Vines are being reborn. Sap begins to flow upward. Days are warming. Buds swell, popcorn fuzz peeks out, and tiny iridescent green leaves and stems stretch forth. These fragile shoots are vulnerable and need protection. They are tender and tasty to rabbits, deer, and insects, perfect for mildew, and can be blackened by frost. Wine growers are guardians and guides during these critical times.

Randle Johnson, viticulturist

The pond and vineyards at Artesa Winery with spring mustard in bloom.

Springtime mustard in the vineyards and a red barn in the Carneros region.
The barn was relocated from Marysville and reconstructed in 1940, and has been known by
the locals as "Muir's Barn." The property is now owned by the Lindell family. (overleaf)

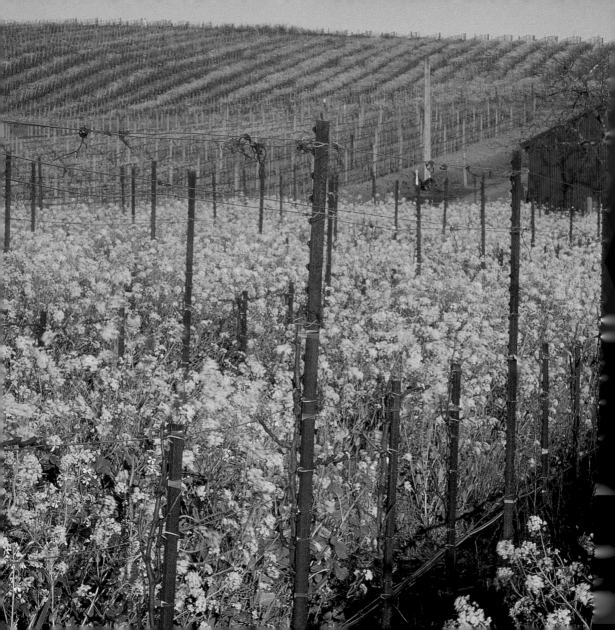

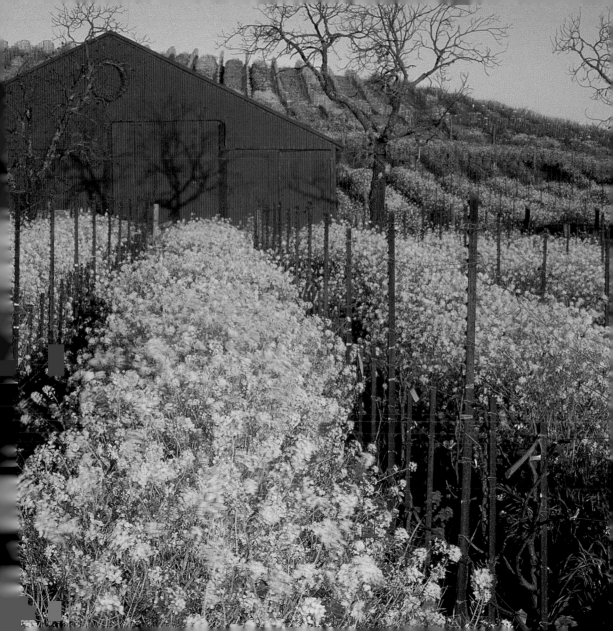

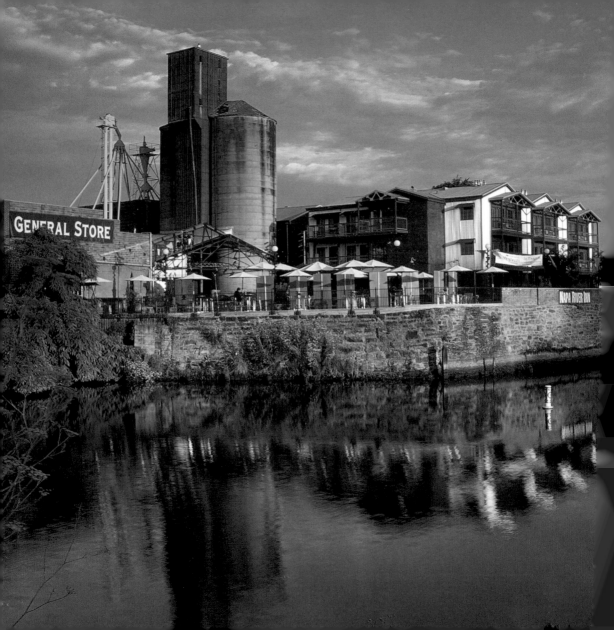

VITICULTURE is a profound and ancient art. The simplest of farmers, if it is their calling, may triumph in it; the ablest of scientists may be baffled by it.

Idwal Jones, wine connoisseur

15

The Napa River with the historic Old Mill
(now the Napa River Inn) and the boat dock on the river in
downtown Napa. Built in 1884 and listed in the National
Registry of Historic Places, the Napa Mill is the largest historic
redevelopment undertaking in the history of Napa.

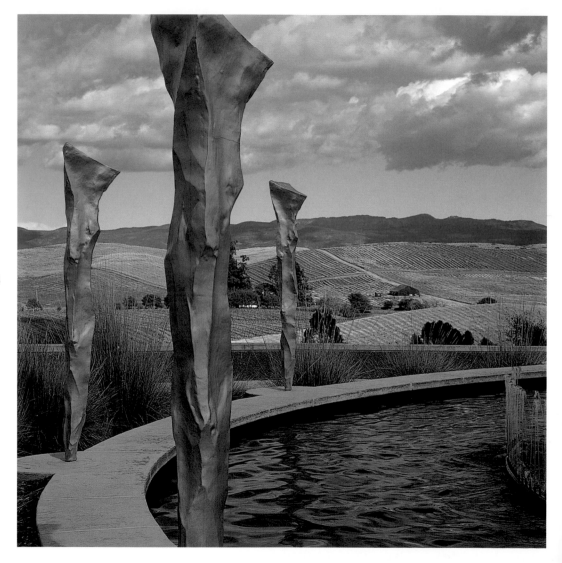

THE beauty of the wine is not like the beauty of an autumn leaf on the vine, or of vineyards on rolling hills, or of the girl who is always in the advertising posters picking the grapes. The beauty of wine is a controlled abstract beauty expressing the intentions of the artist.

To call the winemaker an artist is to pose practical problems. One rarely knows his name, but one can be sure that associated with every glass of great wine is an artist.

<div align="right">William B. Fretter, winemaker</div>

Sculptures by local Napa artist Gordon Heuther adorn the vineyards of Artesa Winery, located in the Carneros region of the Napa Valley.

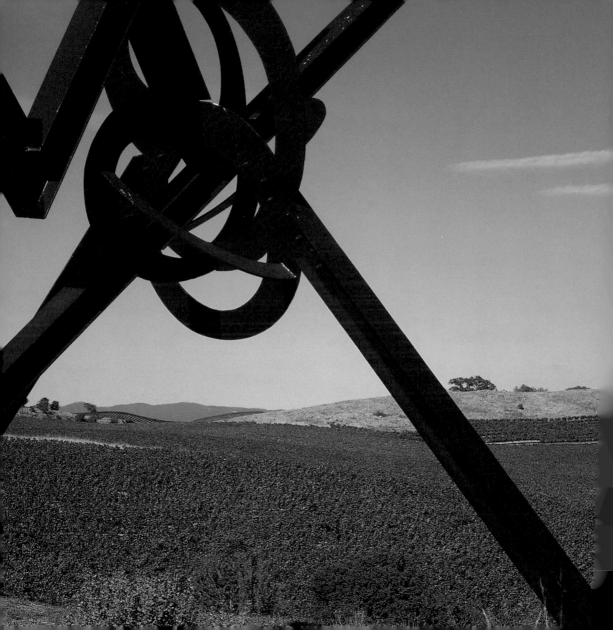

di Rosa Preserve. The larger piece (left) was sculpted by Mark di Suvero in 1987. It is constructed out of steel and entitled Veronica for Veronica di Rosa. The brightly painted cows are two of six cows made of polychromed steel plate. They were designed by Veronica di Rosa, constructed in 1988, and entitled Primary Herd. Veronica, now deceased, was a marvelous artist and the wife of Rene di Rosa, a pioneer grape grower in the Carneros. He now owns and manages the Preserve.

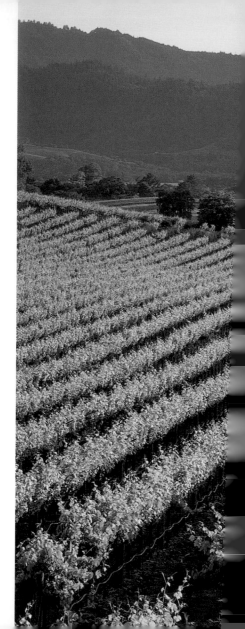

WINE is sunlight,

held together by water.

Galileo

*Late spring sunset over the Cabernet Sauvignon vines of
Screaming Eagle vineyards. Screaming Eagle is owned by Jean
Phillips (Heidi Peterson-Barrett, winemaker) and produces
a Cabernet Sauvignon that has achieved cult status.*

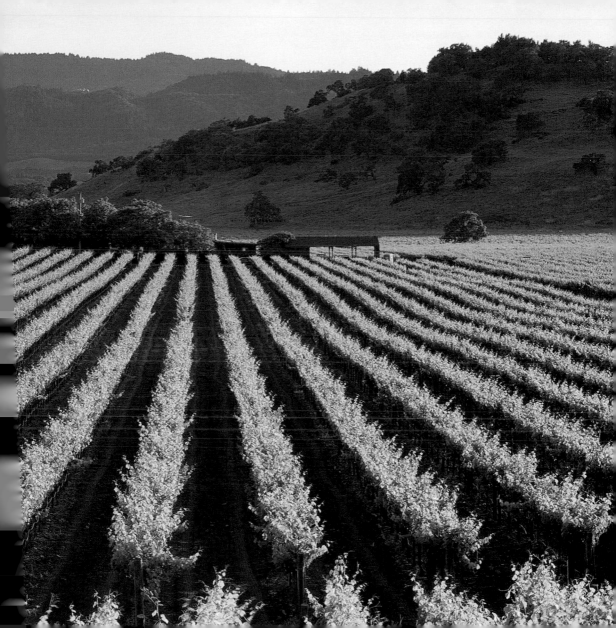

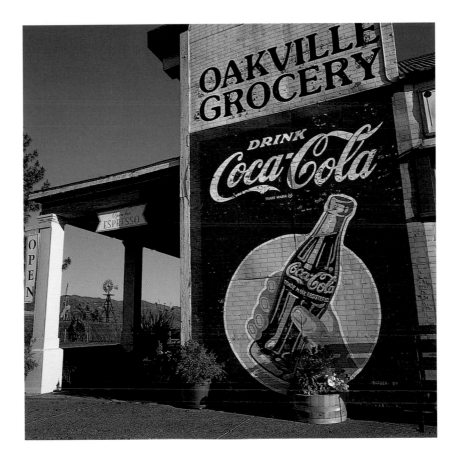

Oakville Grocery.

Opus One winery in Oakville was co-founded by Robert Mondavi and Baron Philippe de Rothschild. Designed by architect Scott Johnson, this extraordinary building was completed in 1991. (overleaf)

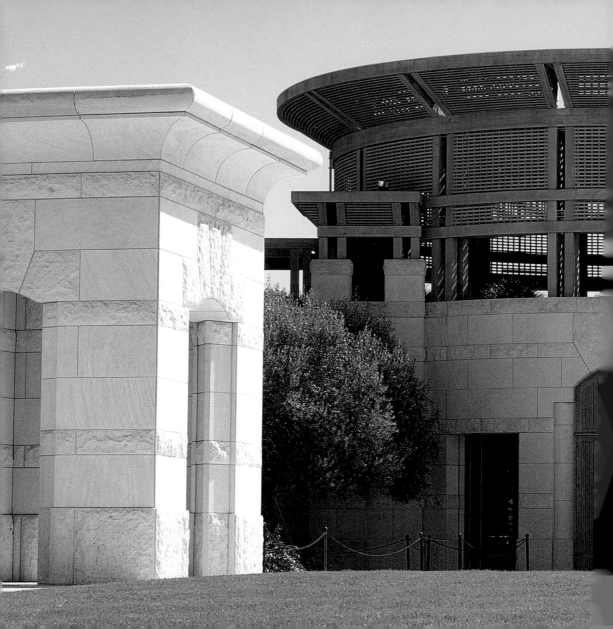

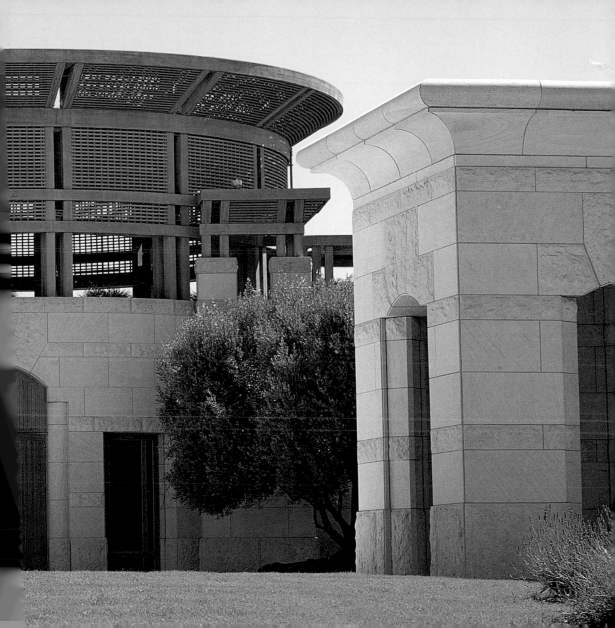

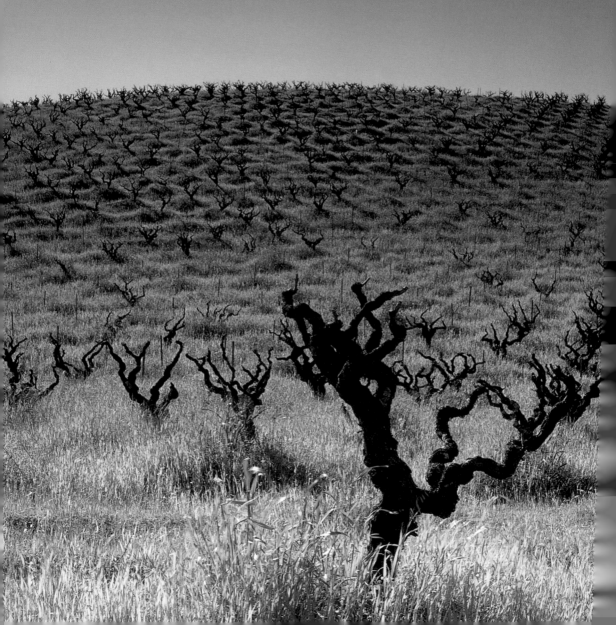

WINE is the most civilized
thing in the world.

Ernest Hemingway

*Seventy-year-old zinfandel vines on the Brandlin Ranch,
Mount Veeder, Mayacamas Mountains.*

EVEN by California's lavish standards,
the valley has long been notable for
exceptional fecundity—a sort of agricultural
Eden—a gift of soils.

Cheryll Aimée Barron, journalist

Red poppies frame the Rudd Vineyards in Oakville.
The vines seen here are Petite Verdot, used for blending with Cabernet Sauvignon. The wines produced
by Rudd are highly regarded. Parker recently rated their Cabernet with a score of 94/96.

Mustard and vineyards off Henry Road in the Carneros District of Napa Valley. (overleaf)

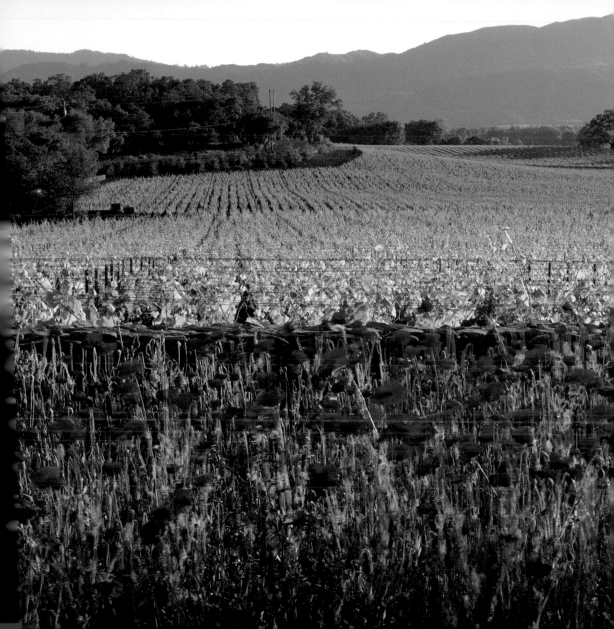

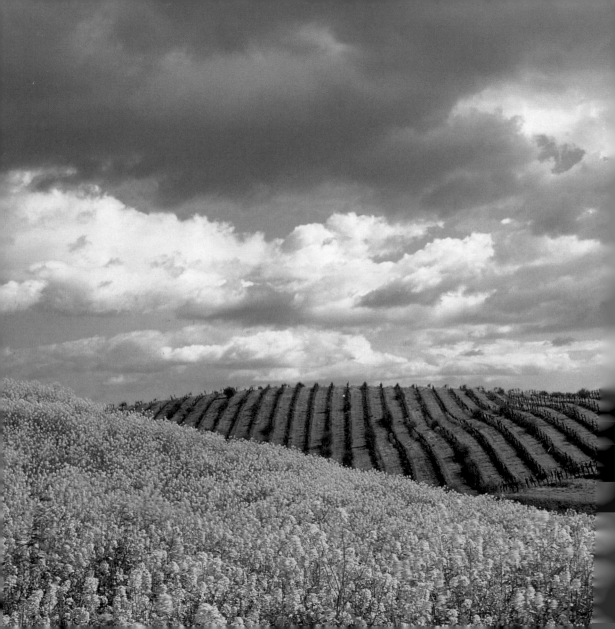

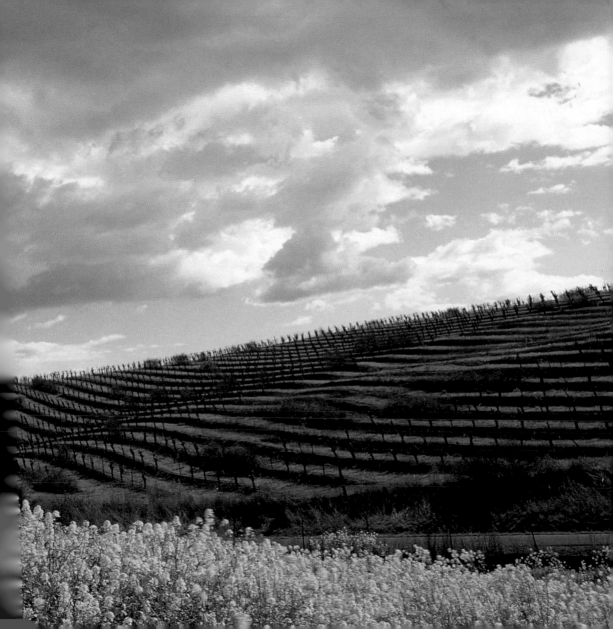

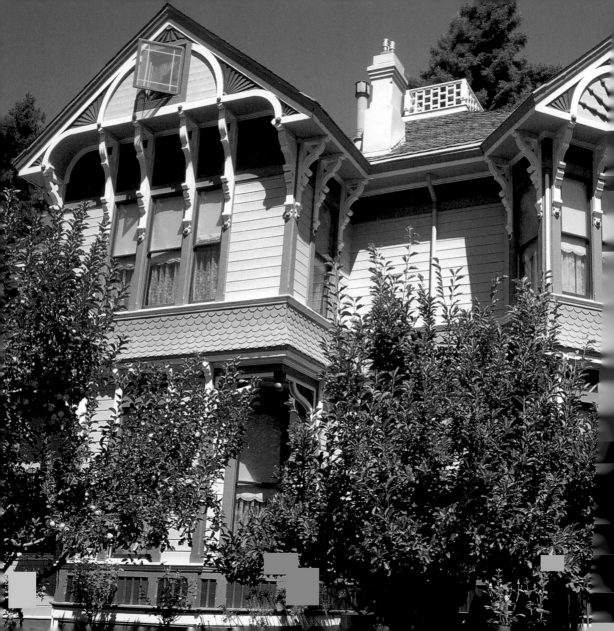

THE lovely Napa Valley
with its neat village, pretty
farms, green trees, and
pretty sites, lay below us, lit
by patches of sunshine here
and there.

William H. Brewer, surveyor

33

*The Manasse Mansion in downtown Napa City now
houses the Blue Violet Inn. Built in 1886, the mansion's
architecture reflects both the Stick style of the 1880s and the
Victorian style of the 1890s. It was owned by Emanuel
Manasse, who was originally from Germany and became the
superintendent of the Sawyer Tannery in 1871. Napa had a
large tanning industry for more than one hundred years.*

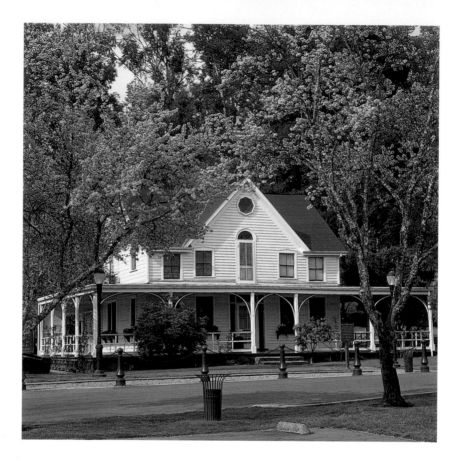

Built in 1856, the Chiles House is one of the oldest structures in the Napa Valley. Located on the 1,000–acre ranch of trailblazer Colonel J. B. Chiles, a member of California's Bear Flag Revolt of 1846, it is now the Niebaum–Coppola Wine Estate, owned by filmmaker Francis Ford Coppola.

Poppies near Lake Berryessa. (opposite)

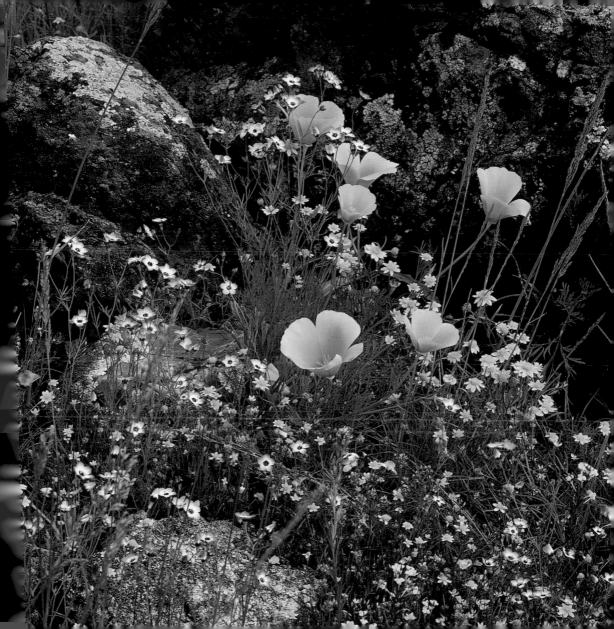

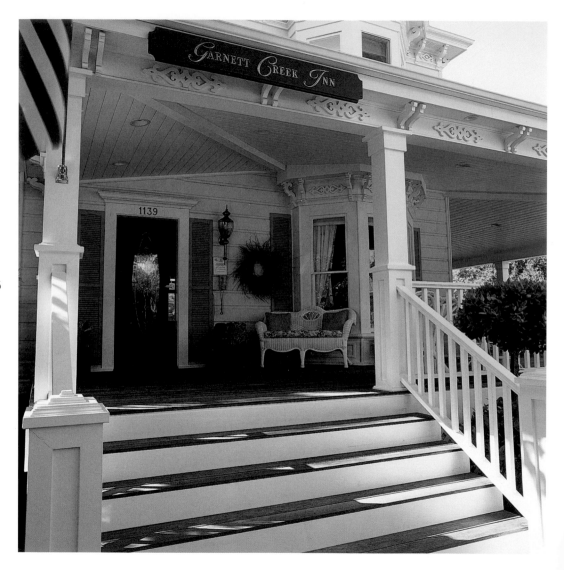

THE pleasant climate in Napa Valley, and the facilities for travel, have already attracted many from the city [San Francisco]. . . . The wealth and culture of the city is in great numbers looking to this valley . . . for a pleasant home where the substantial comforts of rural life may be enjoyed and still the facilities of a rapid transit place them at the doors of the metropolis.

Charles A. Menefee, journalist, 1873

Garnett Creek Inn, Calistoga. This home was originally built in the early 1870s for Charles Ayer in the Italiante Victorian style and was restored in 2001 as an inn.

NAPA Valley means many things to many people—from the scenery with fabulous vineyards surrounded by rolling hills, to the landscape bathed in an almost perfect climate.

Robert and Margrit Mondavi, vintners

Lupine and oak trees at Joseph Phelps Vineyards in St. Helena.

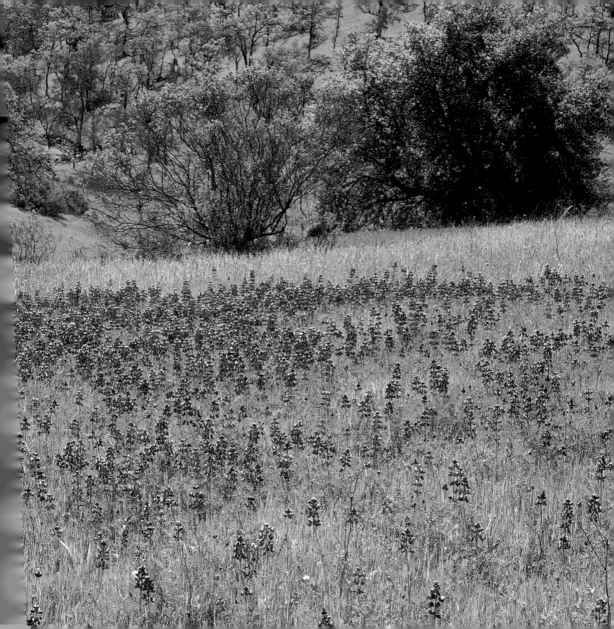

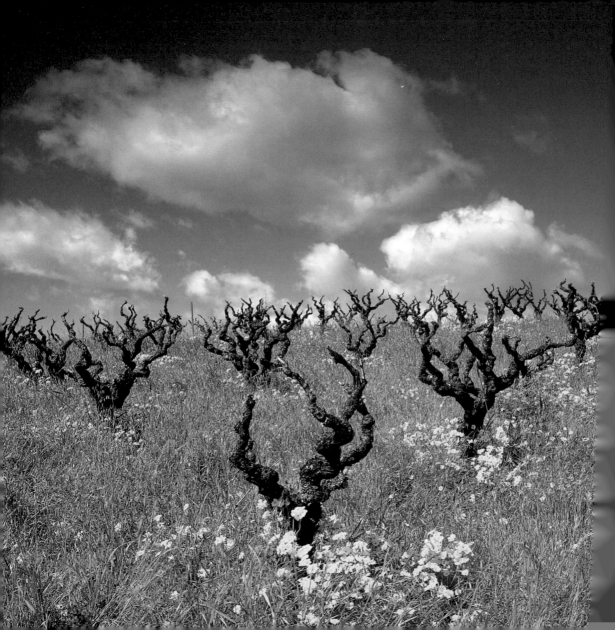

MUSTARD, a cover crop planted between vineyard rows to hold and replenish the soil during winter rains, flips the Valley's summer color scheme on its head: grasses that were dry gold in August are verdant, while once-green vineyards have turned golden.

Thom Elkjer

Head pruned vines on the Brandlin Ranch on Mount Veeder.

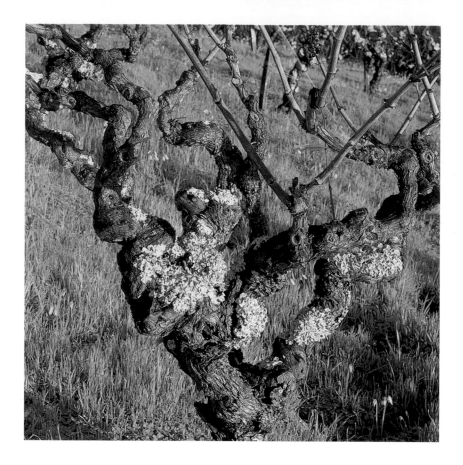

This is a dormant zinfandel vine on the Brandlin Ranch.
The lichens on the vine attest to the vine's age. The vineyard produces less than
a ton of grapes per acre, resulting in an amazingly concentrated wine with great flavor.

Mustard and vineyards off Henry Road in the Carneros District of Napa Valley. (opposite)

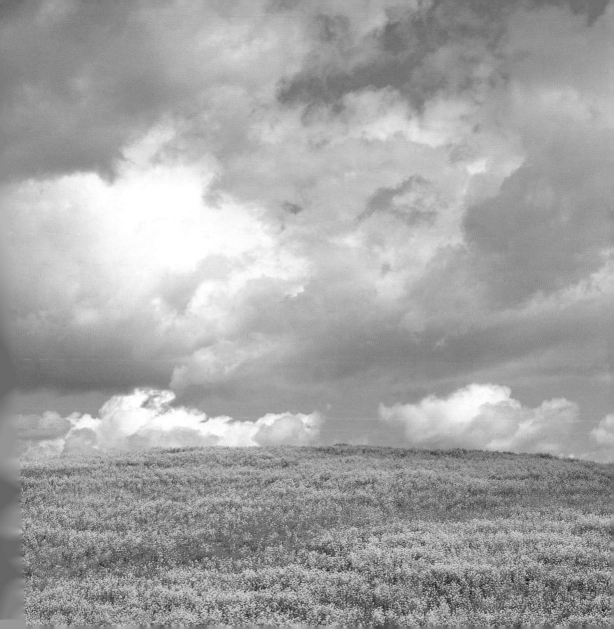

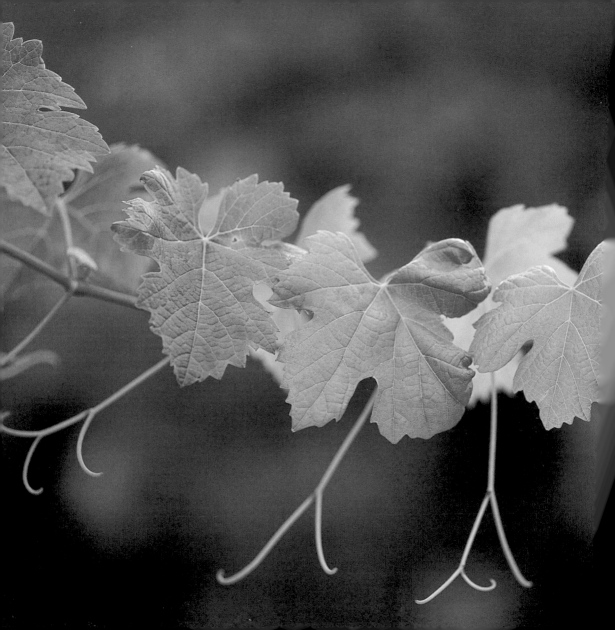

WINE Country. Rows of leafy vines reaching toward the sun; warm, languid afternoons in the dappled sunlight spent sipping a new wine; serene moments of introspection and air perfumed by honeysuckle; and casual, convivial meals enjoyed outdoors with family and close friends. These two words conjure a complete lifestyle—a style of living.

Anthony Dias Blue,
wine editor, *Gourmet Magazine*

Cabernet Sauvignon vine in late spring with tendrils reaching. From the Walker/Pacey Vineyard.

THOSE loads and pockets of earth,
more precious than the precious ores,
that yield inimitable fragrance and
soft fire; those virtuous Bonanzas,
where the soil has sublimated under
sun and stars to something finer, and
the wine is bottled poetry.

Robert Louis Stevenson

Copia—The American Center for Wine, Food, and the Arts—in downtown Napa.

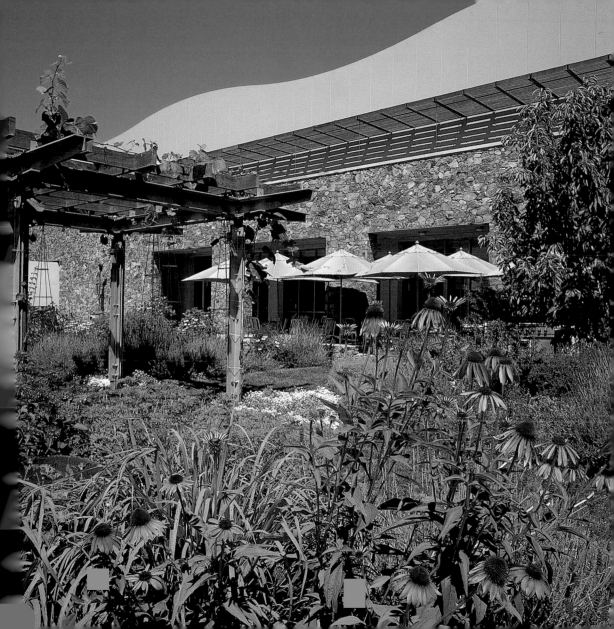

WHEN I came to the Napa Valley I realized I wouldn't have to die to go to paradise. I could work in paradise.

Michael Grgich, vintner

Napa Valley Iris Farm, located in Steele Canyon near Lake Berryessa.

These dormant Cabernet vines with mustard growing among them on the Walker/Pacey Ranch are located on the western hills overlooking the Napa Valley. This vineyard grows select Cabernet grapes for Silver Oak Cellars. (overleaf)

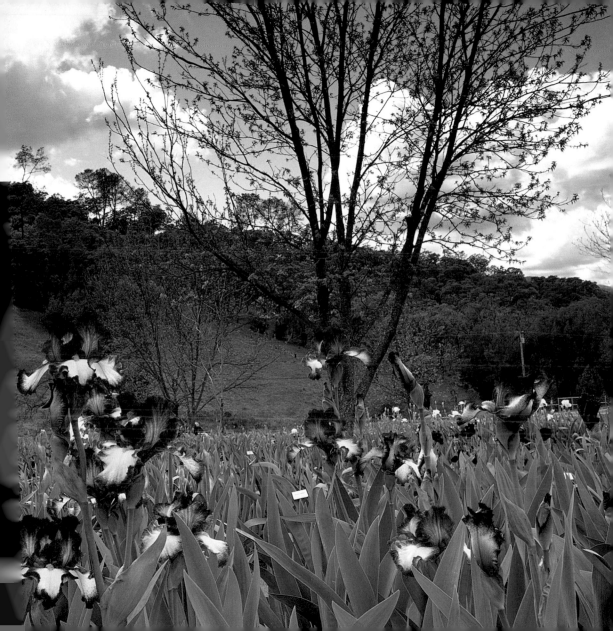

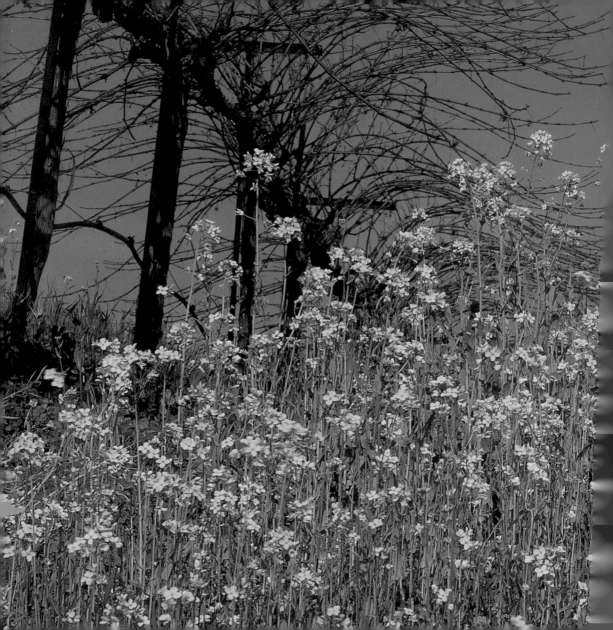

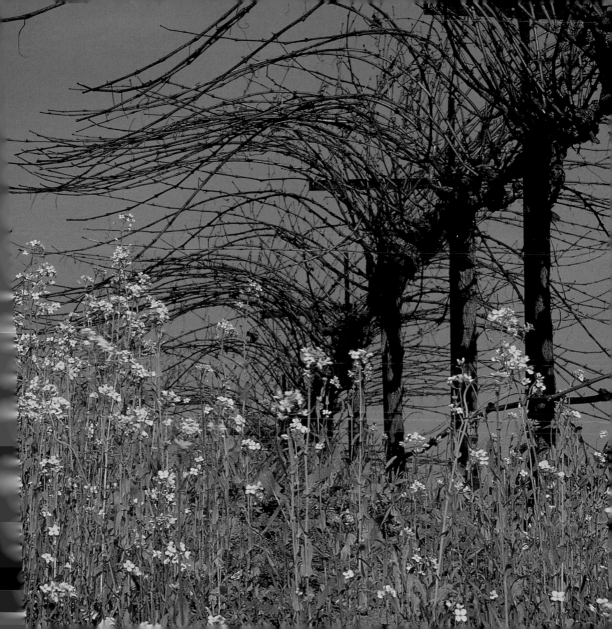

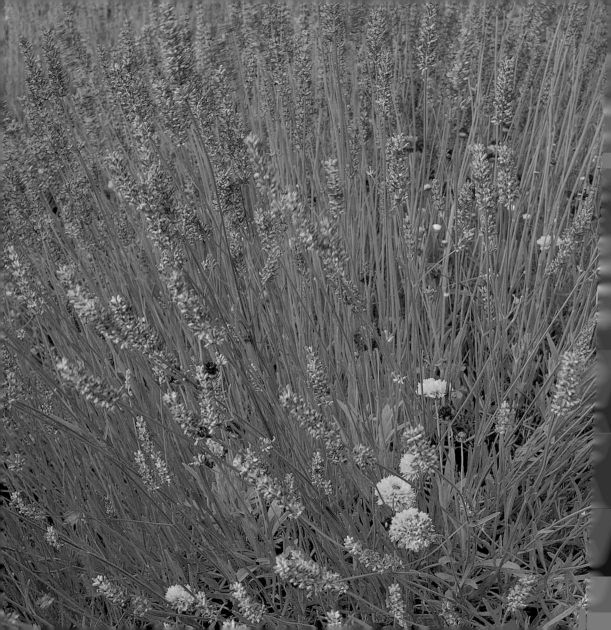

SUMMER

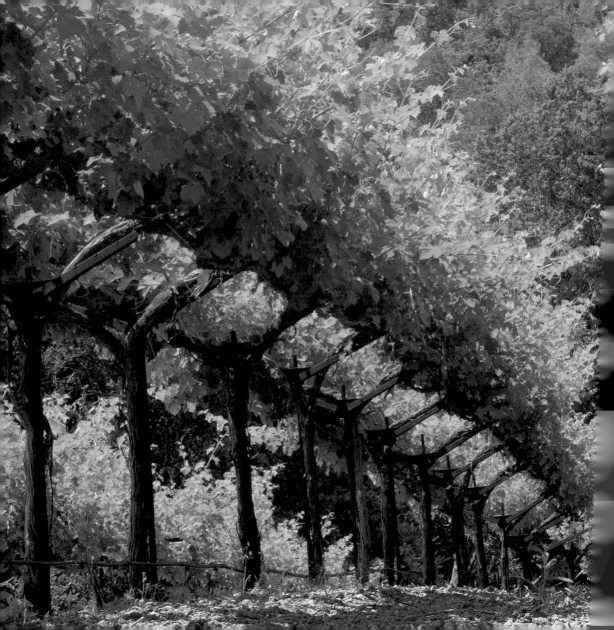

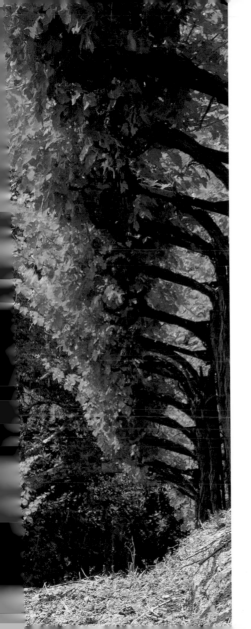

OVERHEAD and on
all sides a bower of green
and tangled thicket, still
fragrant and still flower-
bespangled.

Robert Louis Stevenson

*Lavender at entrance of Niebaum-Coppola
Estate Winery.* (preceding spread)

*Early summer at the Walker/Pacey Vineyard
in the western hills overlooking the Napa Valley.
The vineyard produces select Cabernet Sauvignon grapes.*

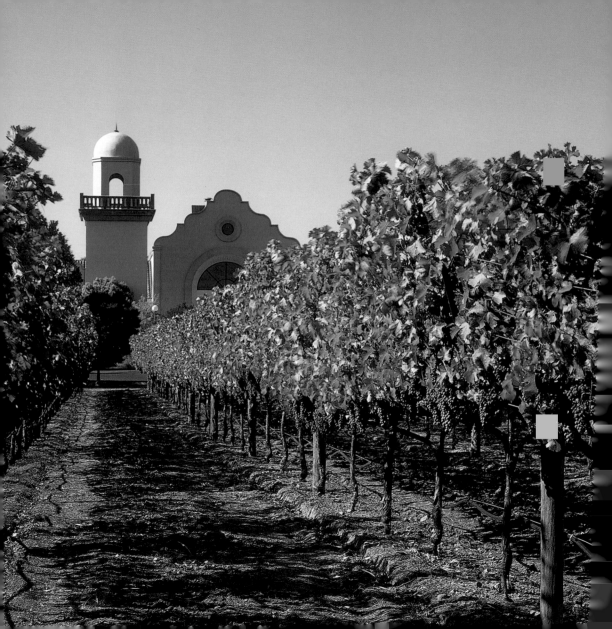

IN the luxuriance of a bowl of grapes set out in ritual display, in a bottle of wine, the soil and sunshine of California reached millions for whom that distant place would henceforth be envisioned as a sun-graced land resplendent with the goodness of the fruitful earth.

Kevin Starr, California historian

Groth Vineyards and Winery in Oakville with Cabernet vineyard in the foreground.

Nickel & Nickel Winery in Oakville. The Gleason Barn was originally built in 1770 in Meridian, NH by the Gleason Family. Spared demolition in 2001, it was carefully restored, dismantled, and shipped in pieces to Nickel & Nickel.

The Napa Valley Vintners Association's Wine Auction at Meadowood. Through the auction, the Vintners have contributed $50 million for health care, youth programs, and housing to those in need over the past twenty years. (opposite)

THE most wonderful part of being a chef in Northern California is that you can grow your own salad greens and herbs and lots of vegetables, too, for ten to twelve months of the year. . . . My rule is simple—eat from the garden whenever you can. It's nice to let Mother Nature write your menu.

Cindy Pawlcyn, chef, Mustards Grill

Organic vegetable garden at Mustards Grill in Yountville
is a source of fresh vegetables for the restaurant.

62

Philippe Jeanty's new French Country Restaurant, "Pére Jeanty," in Yountville.

Sunflowers at the Farmers' Market in St. Helena. (opposite)

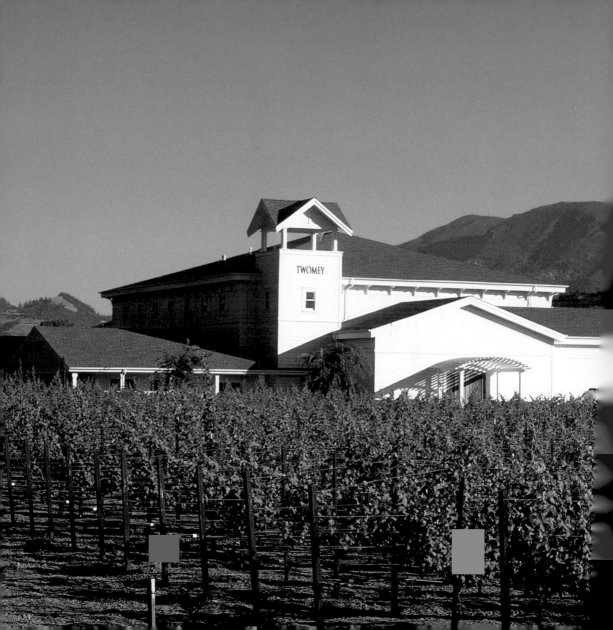

WHEN I take you to the Valley, you'll see the blue hills on the left and the blue hills on the right, the rainbow and the vineyards under the rainbow late in the rainy season, and maybe you'll say, "There it is, that's it!"

Ursula K. Le Guin

65

Twomey Cellars, makers of fine single-vineyard Merlot.

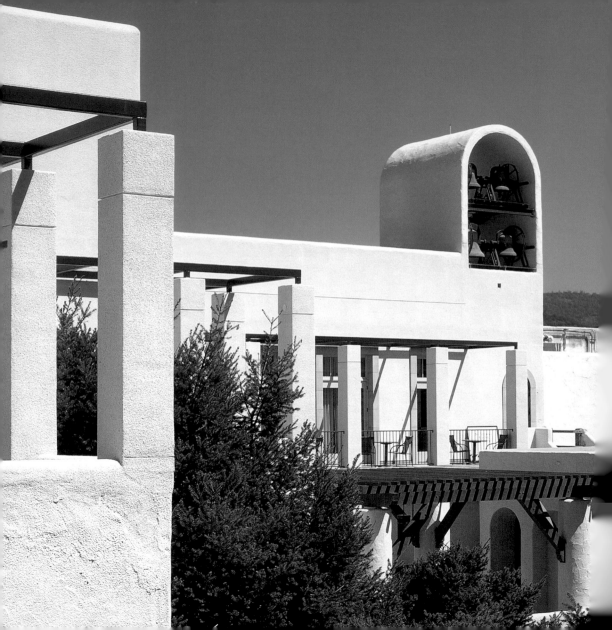

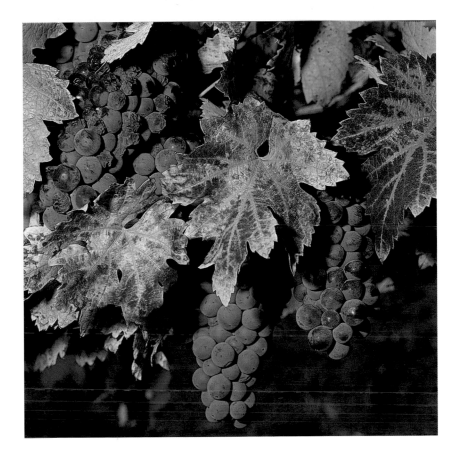

"Old Vine" zinfandel grapes shortly before harvest. Peter Franus Vineyard, Mount Veeder.

The bell tower at Sterling Winery. Founded by Englishman Peter Newton,
the Greek-inspired architecture of the building found a new home for the church bells of
St. Dunstan's in London, which was destroyed during World War II. (opposite)

SEEDS begin to mature. Ripening is in full swing. Growers monitor the vines for stress, water judiciously, keep them on the edge, and wait patiently. Fall is approaching. They remove some leaves to allow dappled sunlight to mature the remaining fruit. Fruit is thinned to concentrate flavor intensity in the remaining clusters.

Randle Johnson, viticulturist

68

One hundred-year-old olive trees planted by Jacob Schram in the vineyards of Schramsberg Vineyards. Founded in 1862, Schramsberg Vineyards was the first hillside winery in the Napa Valley.

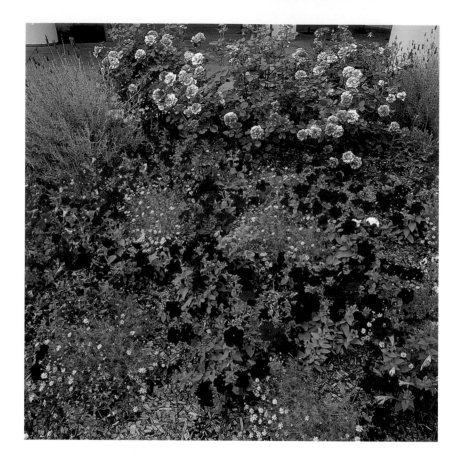

Flower gardens at the foot of the aerial tramway to the winery at Sterling Vineyards.

TO enjoy wine is to partake
of a heritage that stretches
back to the beginnings of
civilization and promises to
add continued pleasure to
our future.

Robert Mondavi

The Riddler's Pond next to the Hospitality Center at Schramsberg Vineyards is anchored by Larry Shank's sculpture entitled "Riddlers Night Out." It is the "riddler's" job to turn the champagne bottle so that the remnants of the yeast settle in the neck for disgorgement prior to adding the dosage (sugar) to make the bubbles. In order to do this the bottle is placed in a rack neck down and a riddler turns it a quarter turn at a time over many days (even weeks) as the yeast gradually accumulates. It's a tedious job and a night out is always welcome!

SUMMER vineyard slopes

Well-ordered.

Lavender's chaos,

Olive trees dust green.

Hot and fragrant

Ancient scents.

Reverend Brad Bunnin

*Harms Vineyards and Lavender Fields are located on the
western hills of the Napa Valley. The lavender was originally
planted as a buffer to insulate the grapes from the glassy-winged
sharpshooter that infected the vines with Pierce's disease.
The vineyard now also produces a range of lavender products.*

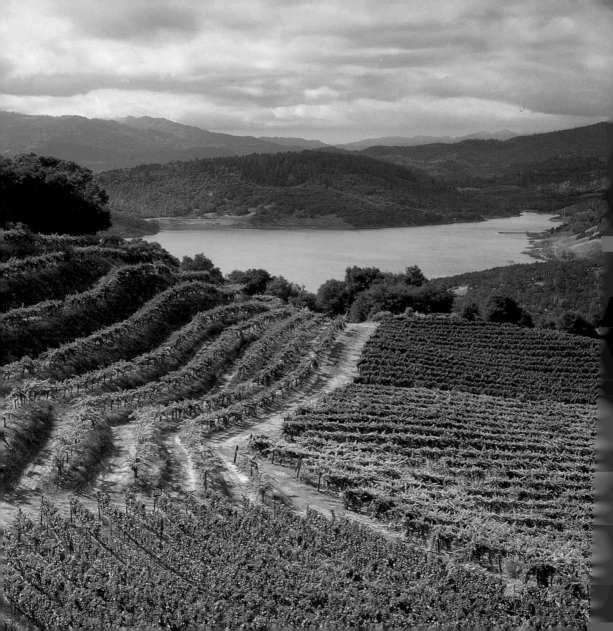

THE vineyards are the world's most expensive landscaping. They're so *geometric*. The land in Napa is stunningly beautiful. The valleys and the rolling hills— these sites are as good as you get.

Olle Lundberg, architect

Long Vineyards. View of vineyards on Pritchard Hill toward Lake Hennessey.

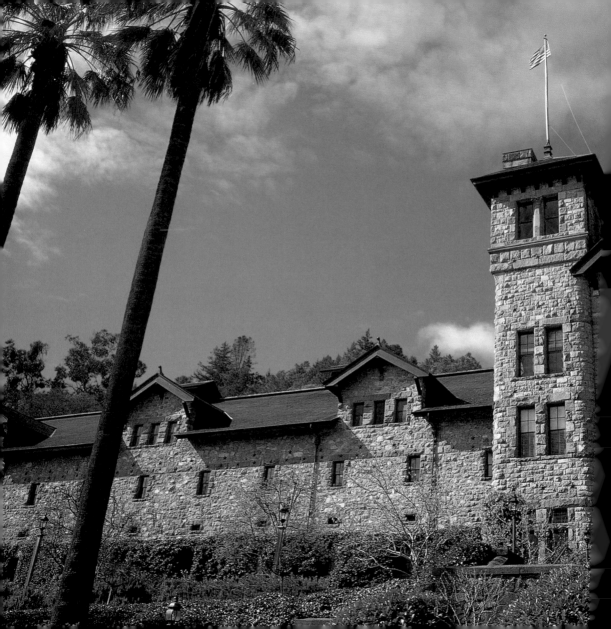

NAPA Valley was about to achieve something unique in America—again. Wine, lately considered the dubious beverage of immigrants, made in basements, would soon be transformed into a symbol of high culture, and winemakers would be heralded as artists. The owners of wineries themselves would be celebrated as a new class. . . . They would invite the public into a romantic association not unlike that involving movie idols and real royalty.

James Conaway, Napa historian

Culinary Institute of America at Greystone. The building formerly housed the Christian Brothers' Greystone Winery.

79

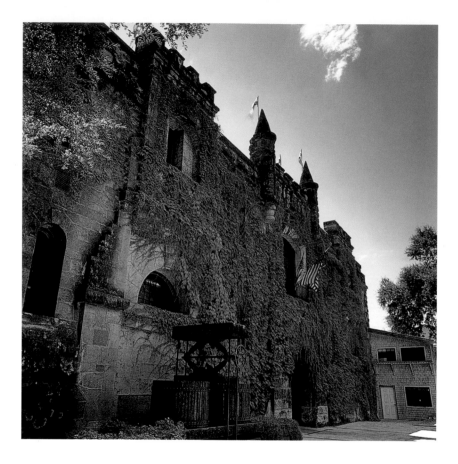

Old stone winery and Jade Lake at Chateau Montelena.

Stony Hill Winery on Spring Mountain in St. Helena.
View across Riesling vineyard toward Mount St. Helena. (overleaf)

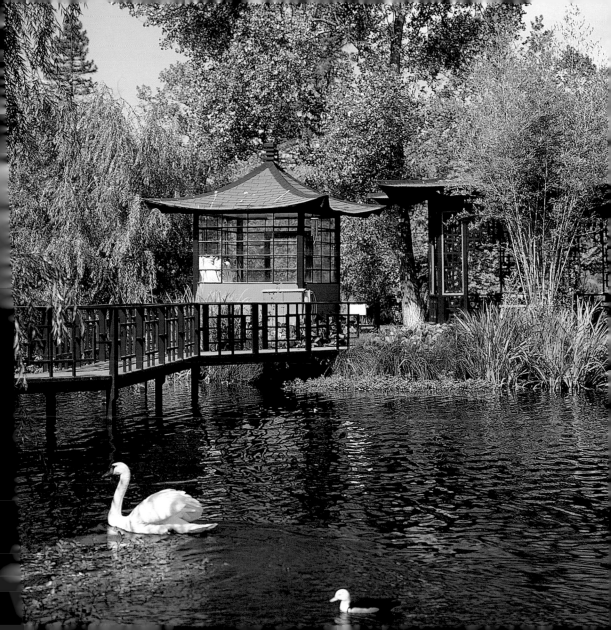

AND there were gardens bright with sinuous rills; Where blossomed many an incense-bearing tree; And here were forests ancient as the hills, Enfolding sunny spots of greenery.

Samuel Taylor Coleridge

The Auberge du Soliel, a restaurant and resort on the eastern hills of the valley in Rutherford, looking westward into the valley.

86

Pouring over the cap at Clos du Val winery during the fermentation of Merlot grapes to enhance the color and flavor of the wine.

Quintessa Winery, designed by Walker Warner Architects of San Francisco, is located along the Silverado Trail near Rutherford. (opposite)

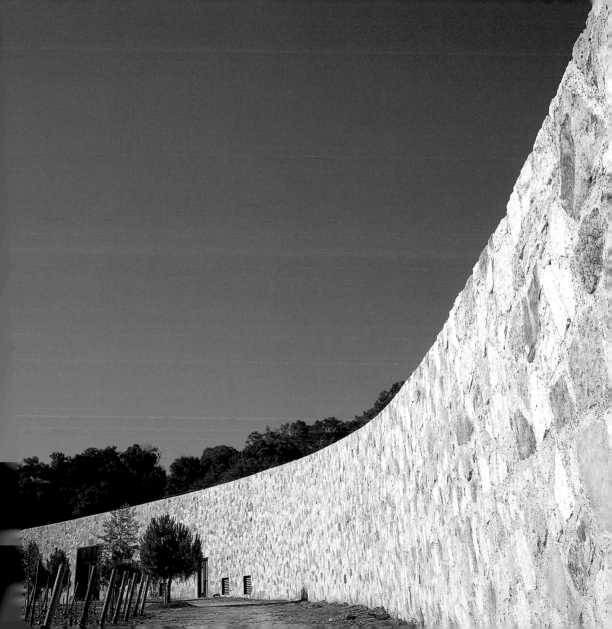

ENTER, then, the Rose-garden when the first sunshine sparkles in the dew, and enjoy with thankful happiness one of the loveliest scenes of earth.... Roses that stretch out their branches upward as if they would kiss the sun.... They blush, they gleam amid their glossy leaves, and never... hath eye seen fairer sight.

S. Reynolds Hole

Mayacamas Vineyards and Winery. Red roses against stone wall of old winery. The winery was built in 1889 by John Henry Fisher, a German immigrant.

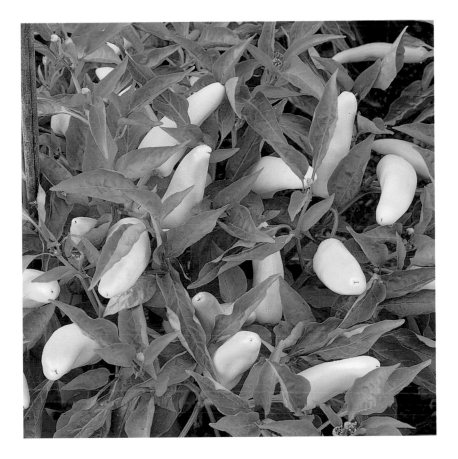

*Gourd and chili peppers in an organic garden at Frogs' Leap Winery. An old ledger
revealed that around the turn of the century, frogs were raised there and sold for $.33 a dozen.
Now home to some of Napa's best wines, their motto is "Time's fun when you're having flies!"*

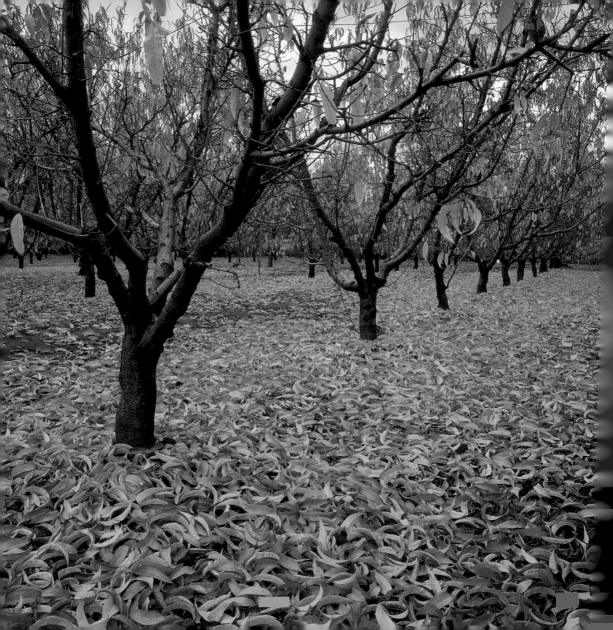

FALL

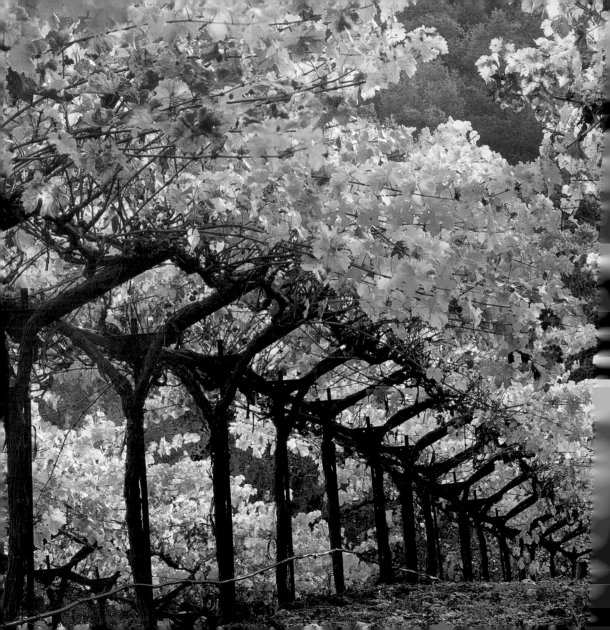

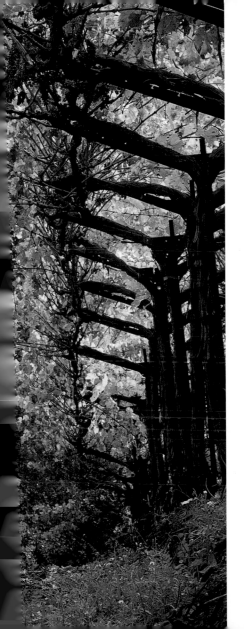

LET us get up early to
the vineyards; Let us see
if the vine flourish,
Whether the tender
grape appear.

95

Song of Solomon 7:12

*Fall leaves in Dr. Wendell Dinwiddies' peach orchard
on the Silverado Trail in St Helena. (preceding spread)*

*Fall colors of the Walker/Pacey Vineyard in
the western hills overlooking the Napa Valley.
The vineyard produces select Cabernet Sauvignon grapes.*

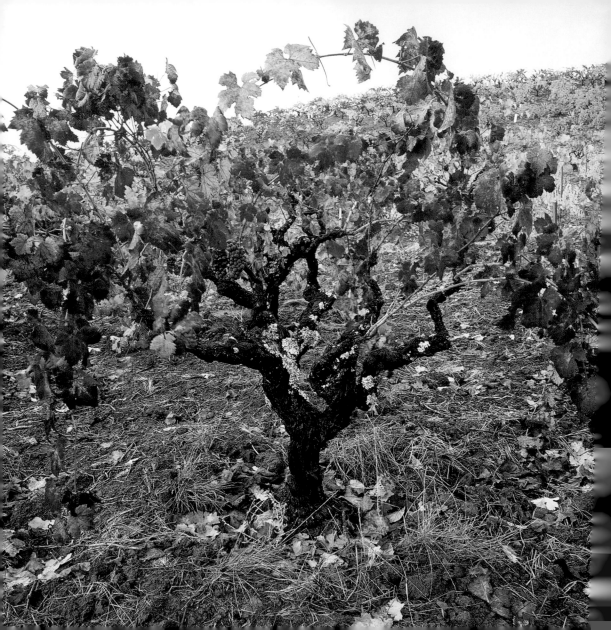

*Cabernet Sauvignon vine following harvest in the
Walker/Pacey Vineyard on the western hillside of the valley.*

"Old Zin" vine in the Peter Franus Vineyard. (opposite)

AS you step into the balloon's gondola, your eyes will gape at the towering, billowing fabric overhead, and your heart will race with wild expectation. Once aloft, the wind guides your craft above countryside blanketed with acres of grapes. Up here, the world seems more serene than you ever imagined possible.

Stephanie C. Bell & Elizabeth Janda, travel writers

A hot air balloon taking off from the Peju Winery in Oakville at sunrise.
The balloon is flown by Joyce Anna Bowen, who operates the Bonaventura Balloon Company in the Napa Valley.

Fall in the Stelling Vineyard/Far Niente Winery. (overleaf)

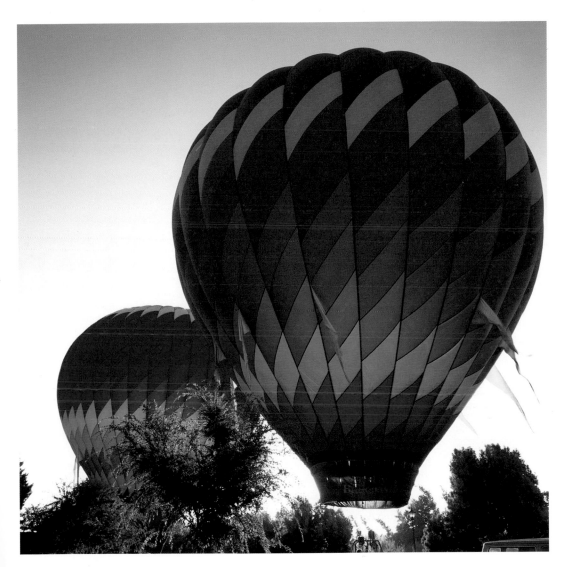

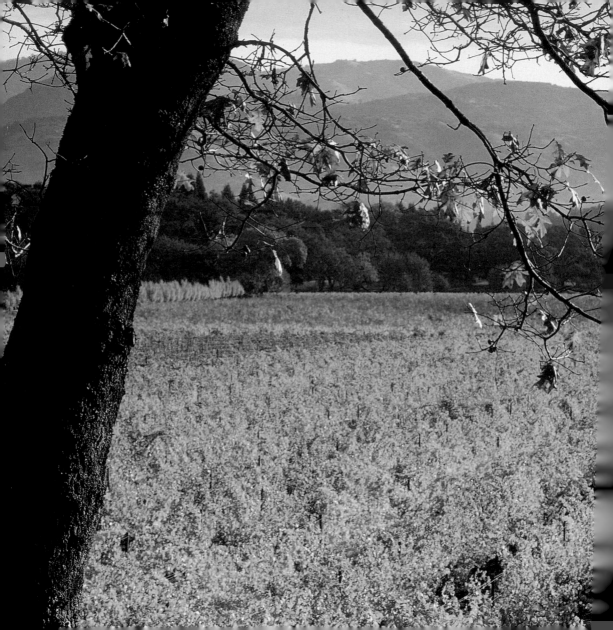

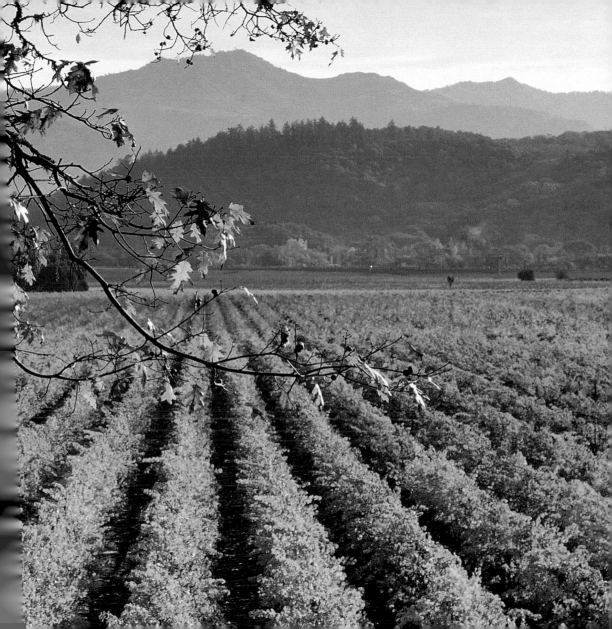

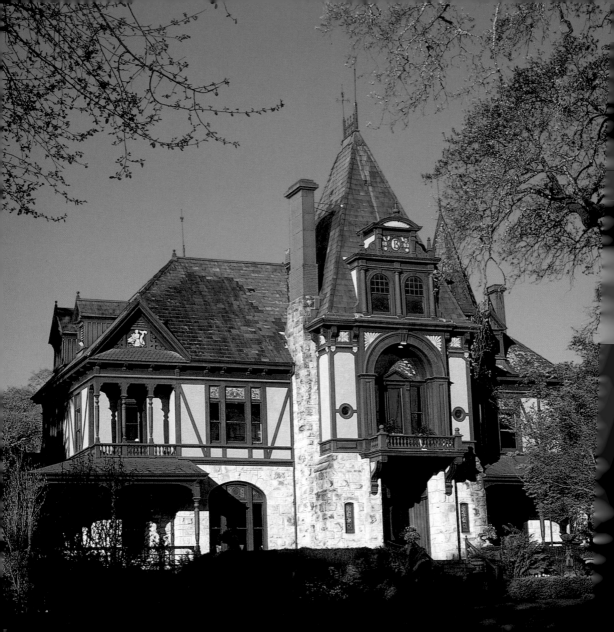

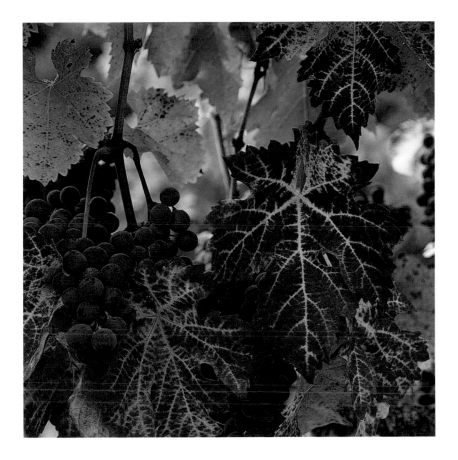

Cabernet Sauvignon grapes shortly before harvest on Spring Mountain.

The Rhine House at Beringer Winery. Built in 1884, this seventeen-room Victorian Mansion is modeled after the Beringer family home in Mainz, Germany. (opposite)

WE create 'living soil'—soil that nourishes itself. We consider ourselves stewards of the land, with our goal being to create vineyards that will not only endure, but improve over time. We seek to accomplish this in a way that preserves the viability of the land for future generations.

Ralph Riva, vintner

"Old Zin" vines at sunrise on the Brandlin Ranch in the Mayacamas Mountains.

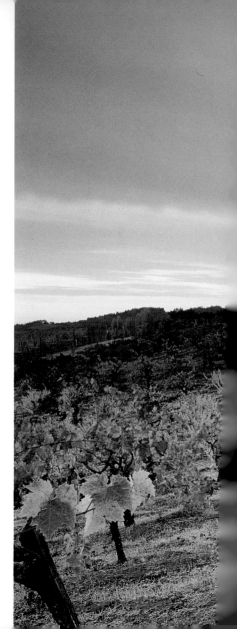

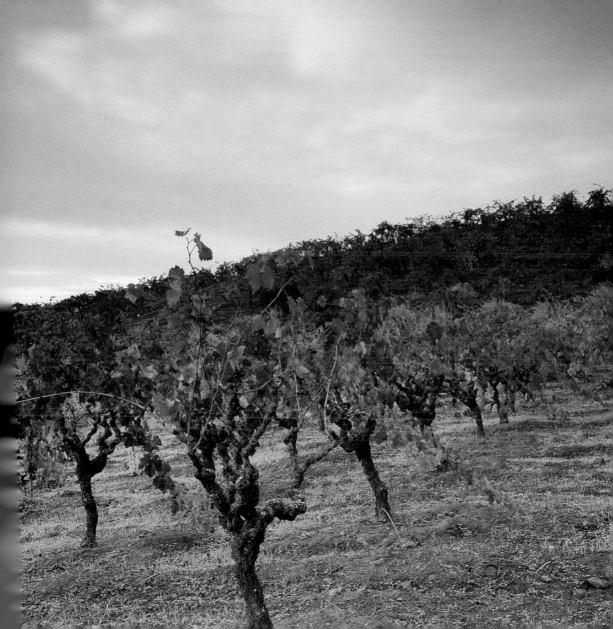

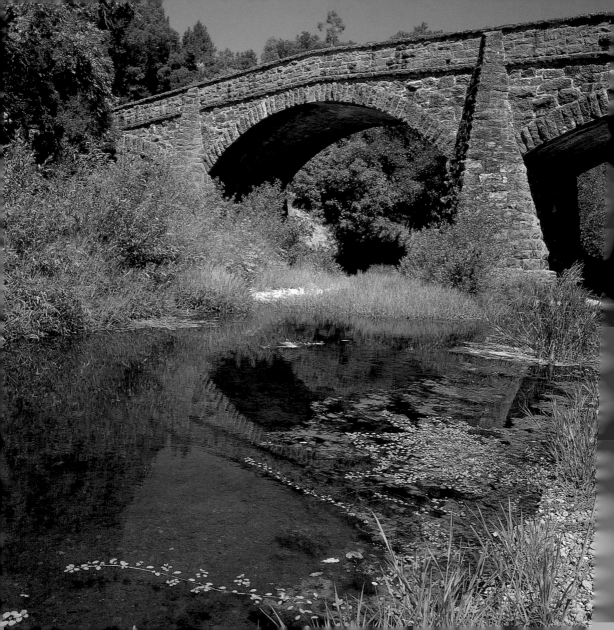

*Constructed in 1879, the original winery at Sutter Home Winery
is still being used today as the visitors' center and tasting room.*

The Pope Street Bridge over the Napa River in St. Helena, constructed in 1894. (opposite)

WHAT wondrous life is this I lead!

Ripe Apples drop about my head!

The Luscious Clusters of the Vine

Upon my mouth do crush their Wine...

Andrew Marvell

Apples ready for harvest in the orchard at the Walker/Pacey Ranch.

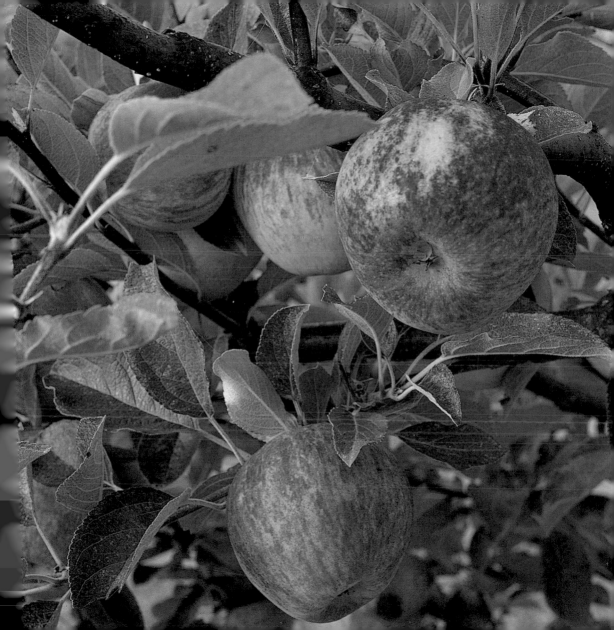

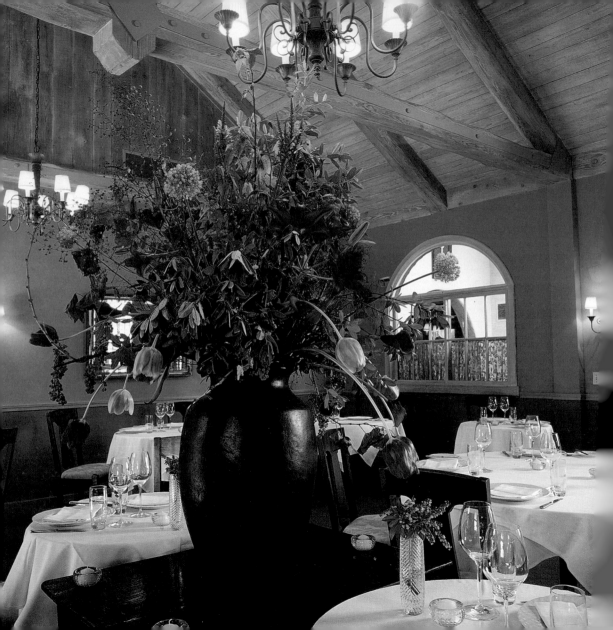

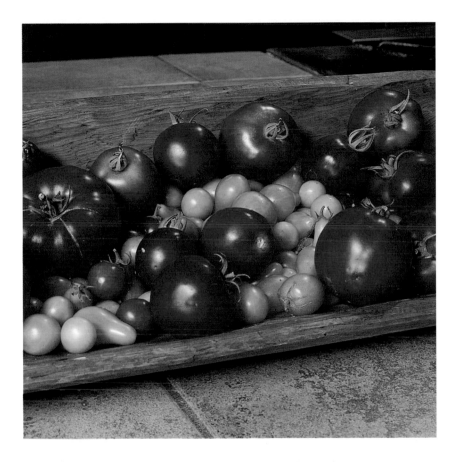

Tomatoes grown in the organic garden of Maria Helm Sinskey at the
Robert Sinskey Vineyards and Winery in the Stag's Leap Viticultural area.

La Toque Restaurant in Rutherford. According to the Zagat Survey, a well-respected restaurant guide,
"... the food and service are over the moon," even inching up in scores equivalent to
"that other restaurant that you heard about but can't get into" in the Napa Valley. (opposite)

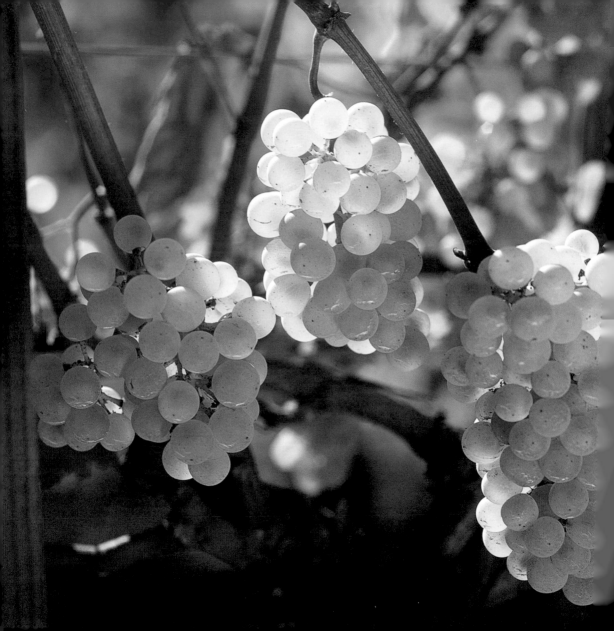

WINE is

earth's answer to

the sun.

Margaret Fuller

113

Chardonnay grapes ready for harvest
at the Pine Ridge Vineyards in the Carneros district.

Maple leaves on a fallen pine log on the drive to Peter and Willinda McCrea's Stony Hill Vineyards.

Maple trees at Schramberg Vineyards. German emigre Jacob Schram first planted the hillsides with grapevines in 1862 and surrounded his home with formal gardens. Jack and Jamie Davies purchased the rudown property in the mid-1960s and lovingly restored its gardens to today's splendor. (opposite)

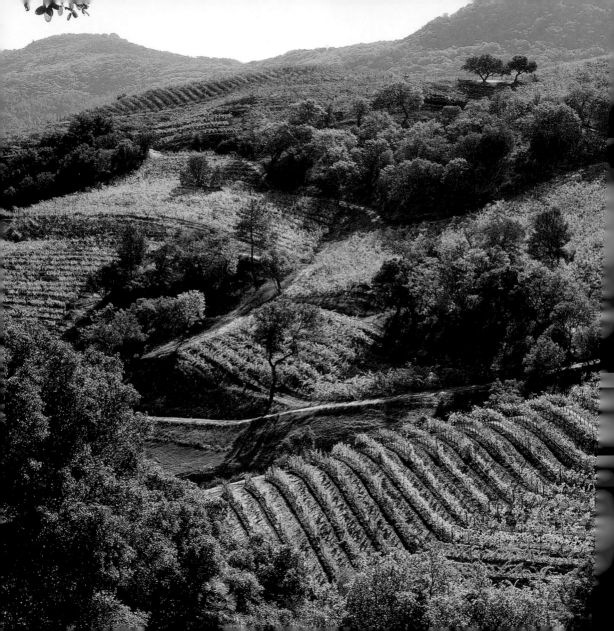

I resisted the charms of the Napa Valley for years, preferring, I thought, the rusticity and diversity of neighboring Sonoma County. Not being a wine maven, I neglected to look at, to feel, the power and beauty of Napa. There is an inevitable, almost British, orderliness to Napa, as if the great Landscape Architect in the sky created it all of a piece.

L. John Harris, food writer

Glorious fall colors light up the vineyards of Kuleto Estate. The 800-acre Napa Valley ranch of restaurateur Pat Kuleto is situated in the rolling hills above the Lake Hennessey and the Napa Valley.

I can no more think of my own life without thinking of wine and wines and where they grew for me and why I drank them when I did and why I picked the grapes and where I opened the oldest procurable bottles, and all that, than I can remember living before I breathed. In other words, wine is life, and my life and wine are inextricable. And the saving grace of all wine's many graces, probably, is that it can never be dull. It is only the people who try to sing about it who may sound flat. But wine is an older thing than we are, and is forgiving of even the most boring explanation of its *élan vital*.

M.F.K. Fisher, gourmet

Clos Pegase Winery was established in 1984 by Jan Schrem and designed by postmodernist architect Michael Graves. In addition to the fine collection of modern sculpture, it is also known for producing highly rated Chardonnay and Cabernet wines.

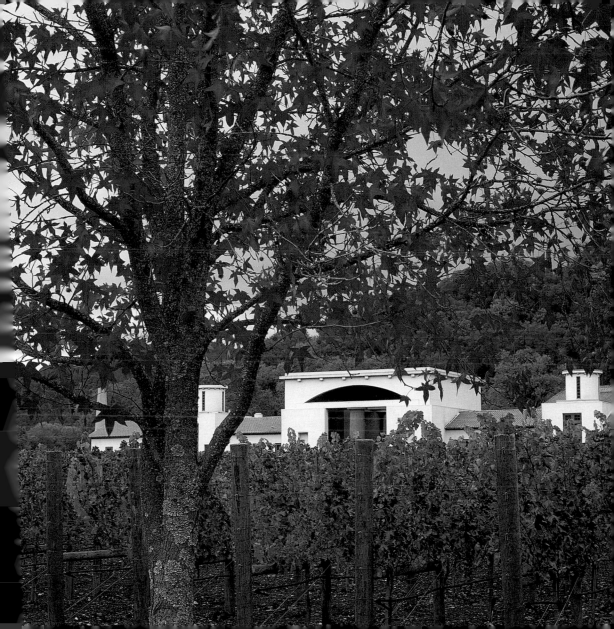

Pears from the organic gardens at Frogs' Leap Winery in Rutherford.

Corison Winery in St. Helena, makers of award-winning Cabernet Sauvignon. (opposite)

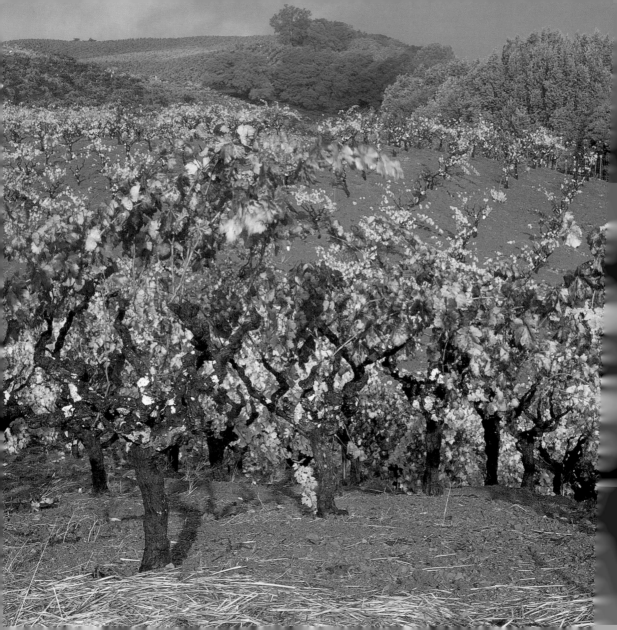

INTO the sweeping floor of vineyards, that heady intoxicating fragrance of grapes being harvested fills the air. The sun is reflecting off the turning fall leaves on the vines like a golden carpet. The road turns and follows along a meandering creek shrouded by a dense canopy of trees.

Sally James, cookbook author

The "Old Zin" vineyard on the Brandlin ranch in the fall, now owned by Cuvaison Winery.

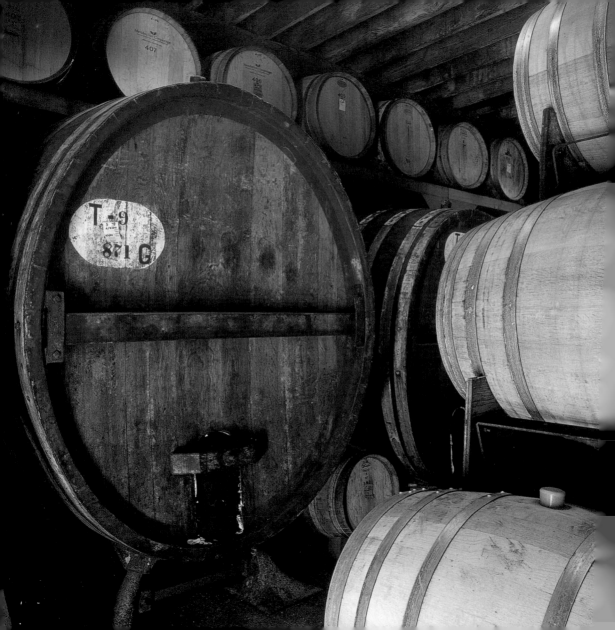

WINTER

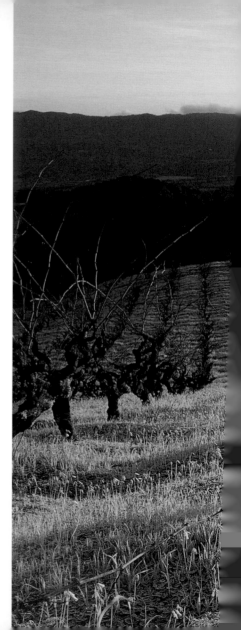

BOUNDED by coastland, desert and forest, shaped by forces older than dinosaurs, Napa Valley is truly a one-of-a-kind gift of nature.

Dawnine Dyer,
viticulturist

Oak oval and barrels in aging cellar at
Mayacamas Winery and Vineyards. (preceding spread)

A winter sunrise over the "Old Zin" vineyard on the
Brandlin ranch, now owned by Cuvaison Winery.

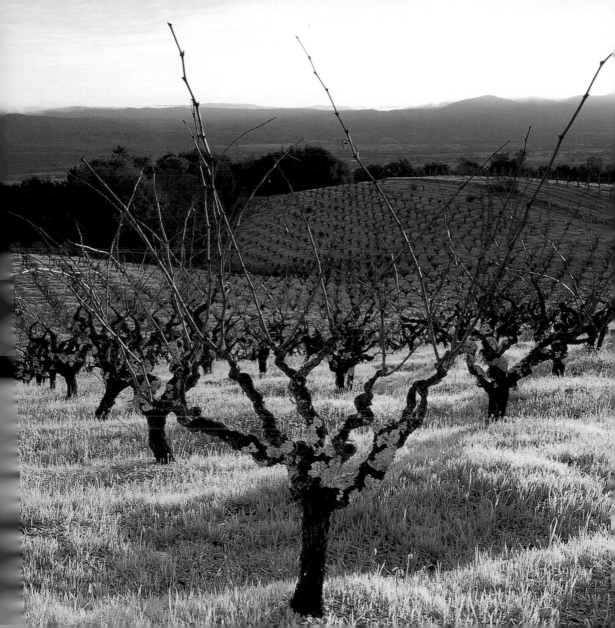

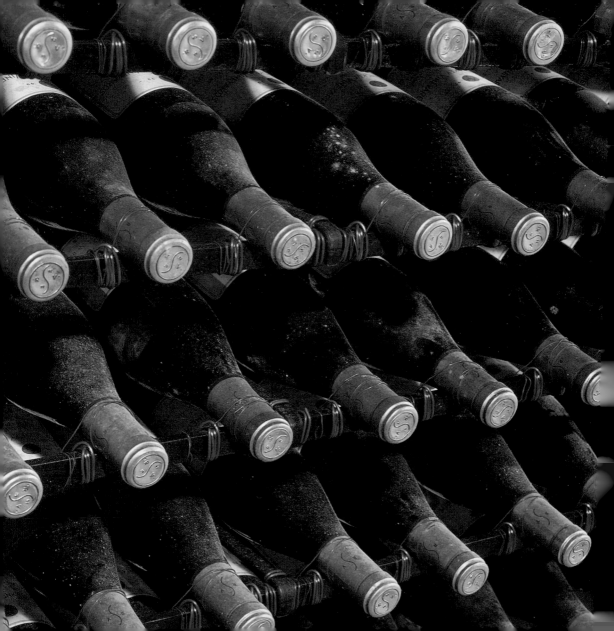

I learned from that early age
to respect wine but not be
awed by it. . . . Wine spilled
on the table was hailed as a
sign of good luck. A bad stain
maybe, but good luck.

Richard Sterling, travel/food writer

Vintage Cabernet Sauvignon in the wine library at Robert Sinskey Winery.

The barrel aging cellar at the historic Stag's Leap Winery. The cave was excavated by Chinese laborers in the 1890s into the volcanic tufa of the Stag's Leap Palisades. (overleaf)

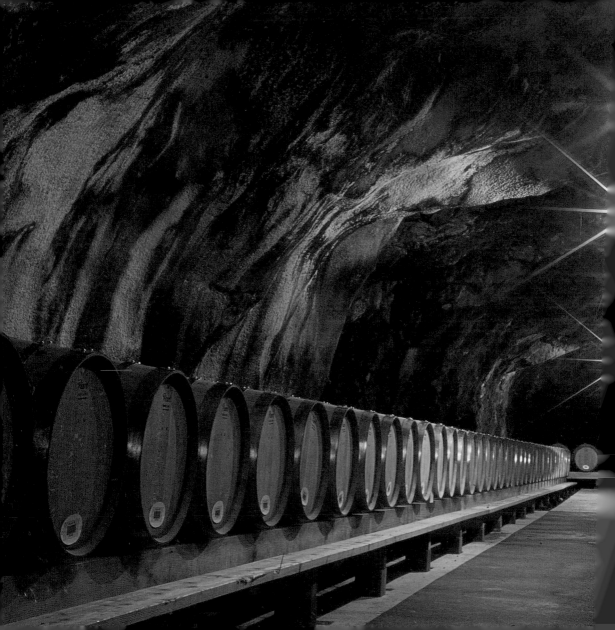

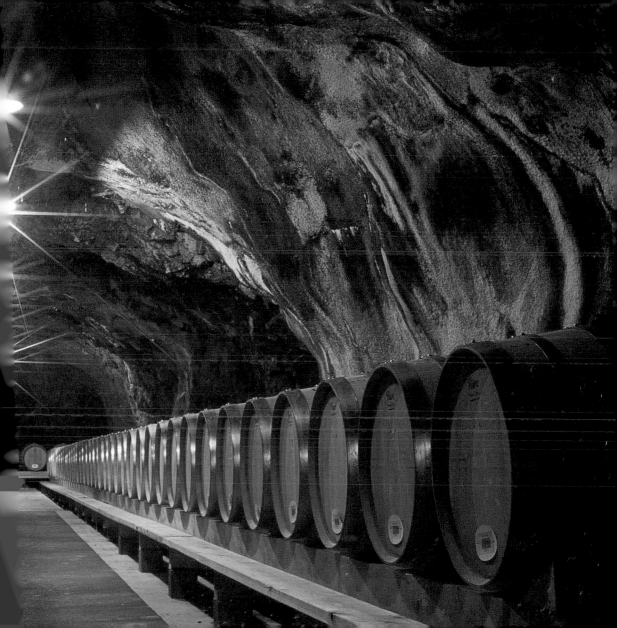

WINE is a look into the heart of a place.

Karen MacNeil, wine connoisseur

This old vineyard is on the Silverado Trail in Calistoga.
It's owned and farmed by winegrower Roy Enderlin,
and named "Rattlesnake Acres" due to the large
number of rattlesnakes found on the property.

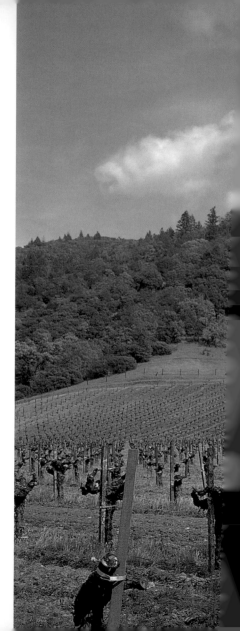

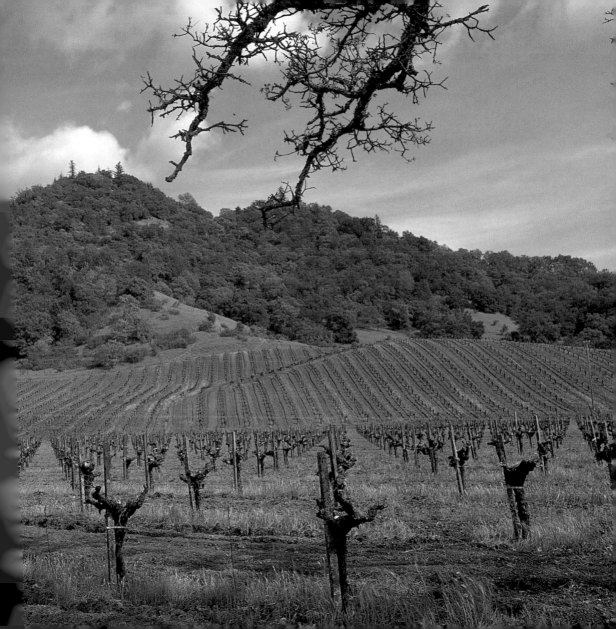

WINEMAKING is part agriculture and part parenting. We are proud to introduce you to what we have worried over and cared for—our wines. They are meant to be shared and enjoyed among friends.

Gene and Katie Trefethen, vinters

135

Historic barn at Frogs' Leap Winery,
now used for fermentation and processing wine.

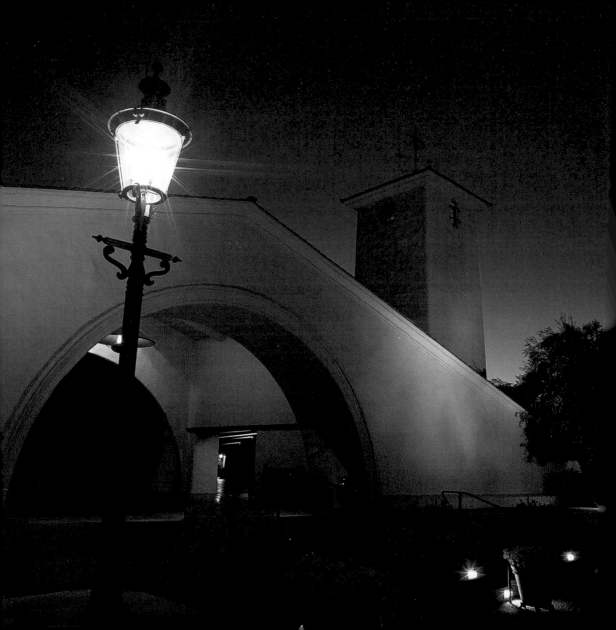

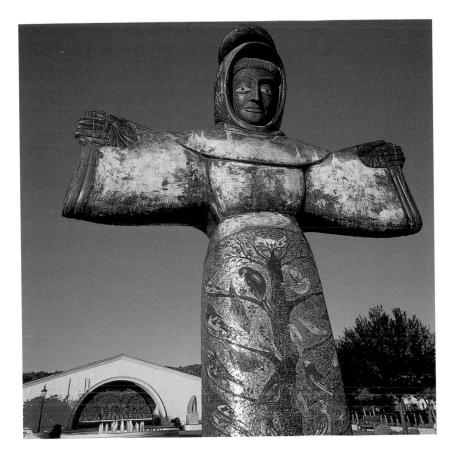

Robert Mondavi Winery in Oakville was started by the patriarch of the valley in 1966.
Its design by architect Cliff May blends California Mission with 1960s Ranch-style architecture.
Statue of St. Francis by Bufano at the Robert Mondavi Winery in Oakville.

The barrel aging cellar at the historic Stag's Leap Winery. The cave was excavated by Chinese laborers
in the 1890s into the volcanic tufa of the Stag's Leap Palisades. (overleaf)

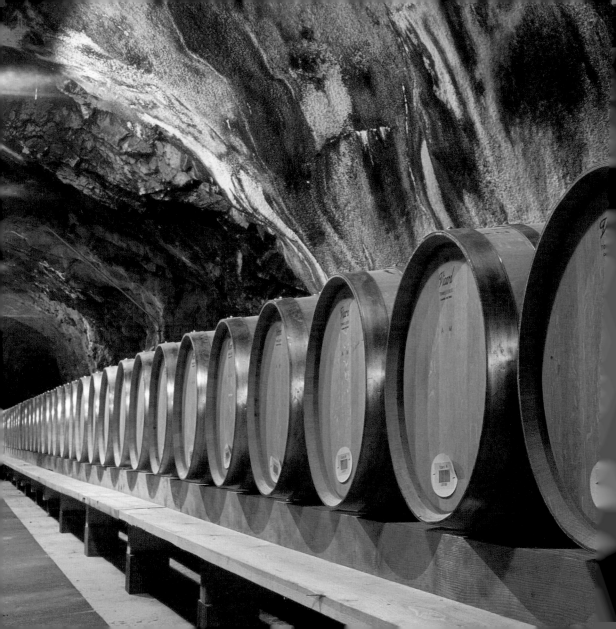

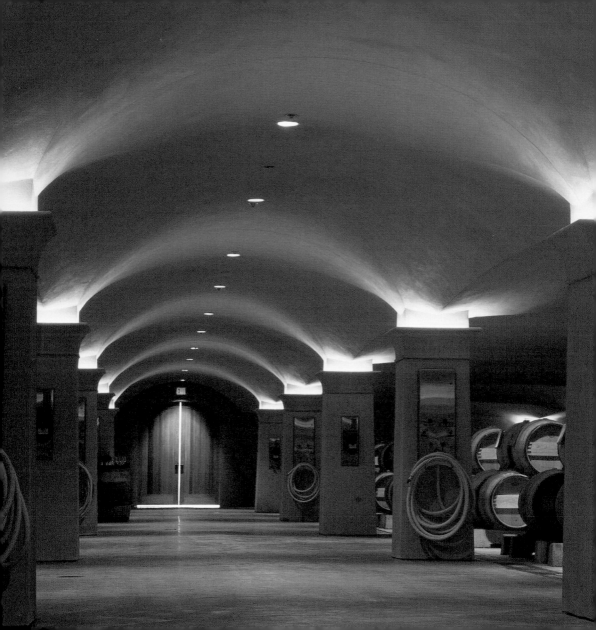

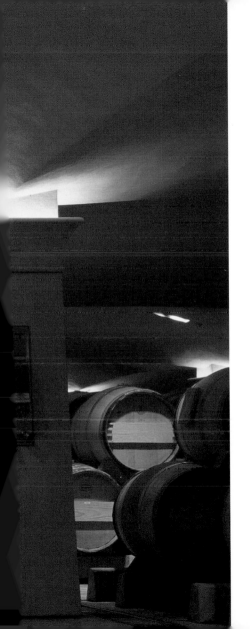

OLD wines are always a reminder of fine days, the past regained. Popular wisdom is right: Wine really is bottled sunshine; that is why it is a cheerful drink, warmth to the heart and soul.

Emile Peynaud, wine educator

141

Barrel aging cellar at Nickel & Nickel Winery in Oakville.

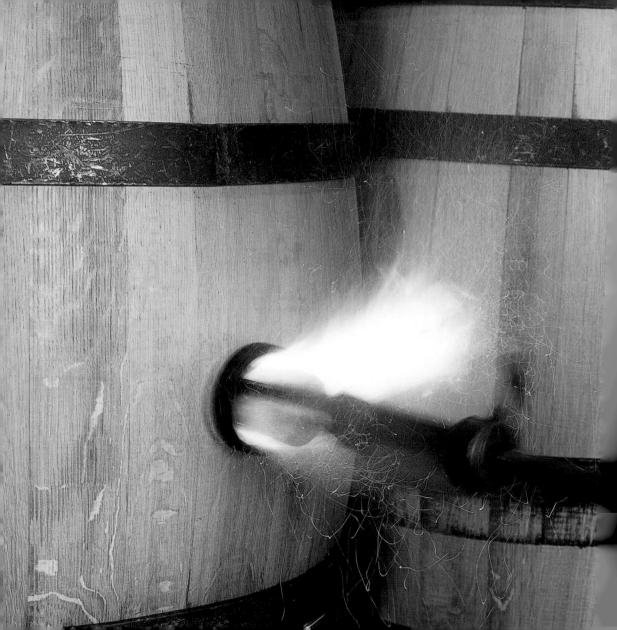

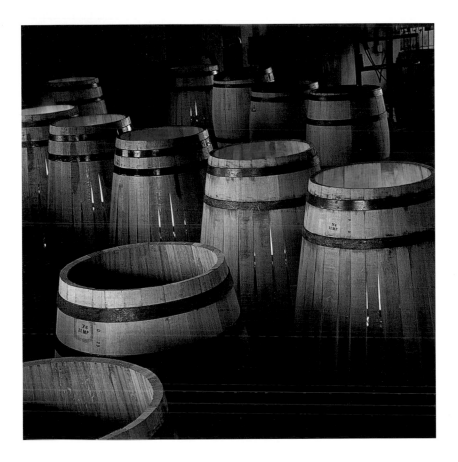

Demptos Cooperage in Napa. Heating the oak
staves to bend into the shape of a barrel and burning the bunghole.

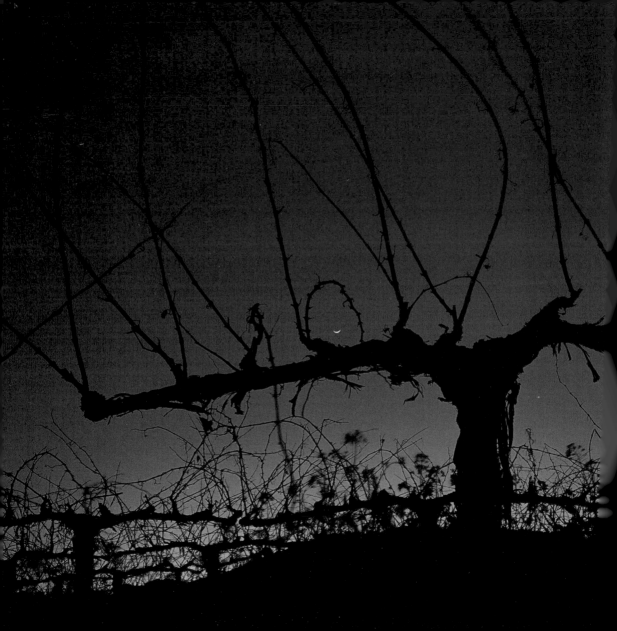

THE geography of
wine is as much an
emotional landscape as
it is a physical terrain.

Anthony Dias Blue

145

A close up of a Chardonnay vine waiting to be pruned after
harvest, shot against a spectacular hillside sunset.
The vine is in the Small Creek Vineyard.

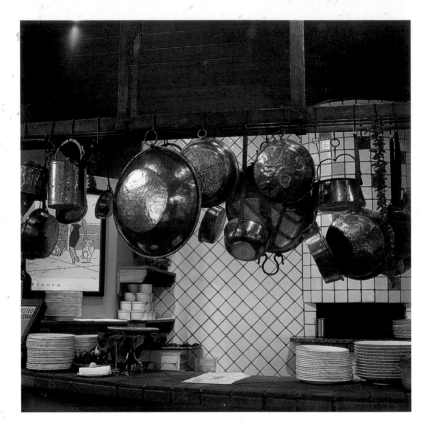

Bistro Don Giovanni, St. Helena Highway, at Howard Lane in Napa.

The Historic Opera House in downtown Napa. Built in 1879 and now a national historic landmark, the Napa Valley Opera House was the center of community life during its heyday, playing host to luminaries such as Jack London, John Philip Sousa, and the legendary soprano Luisa Tetrazzini. Vaudeville shows, masquerade balls, and Temperance rallies were regular fare. The hall went dark in 1914, a victim of changing times. Recently restored, it reopened in 2003. (opposite)

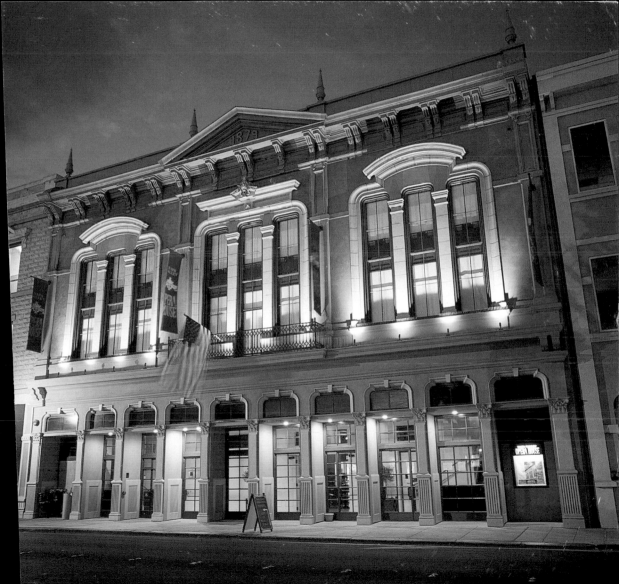

WINE comes in at the mouth
And love comes in at the eye;
That's all we shall know for truth
Before we grow old and die.

William Butler Yeats

Wine displayed for sale at the Oakville Grocery.

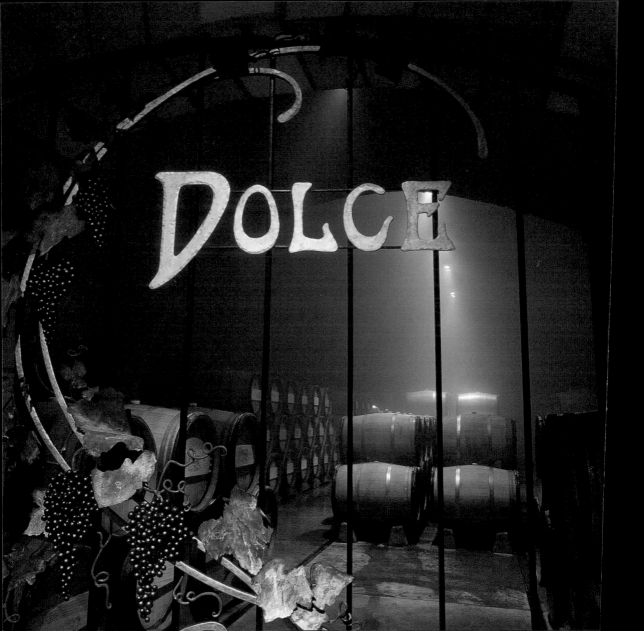

The tasting Room at Kuleto Estate Family Vineyard.

*The wine cave at the Dolce Winery, the only winery in North America
devoted to producing a single, late harvest wine.* (opposite)

I believe in wine as I believe in Nature. I cherish its sacramental and legendary meanings, not to mention its power to intoxicate, and just as Nature can be both kind and hostile, so I believe that if bad wine is bad for you, good wine in moderation does nothing but good.

Jan Morris, travel writer

Barrel aging cellar at the Regusci Winery, constructed in the 1870s.

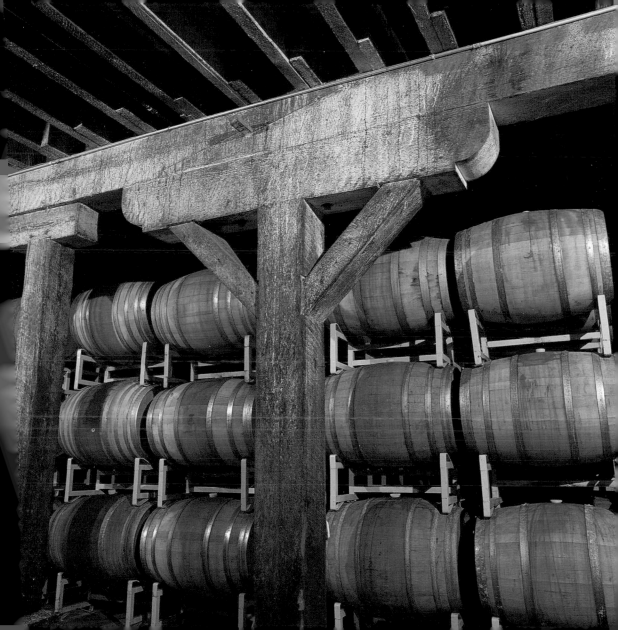

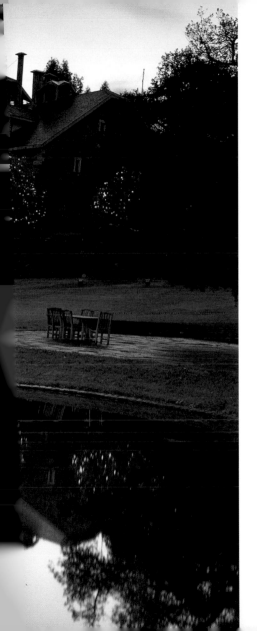

I have always used the term winegrower rather than winemaker because it better expresses my belief that the personality of a great wine is a manifestation of its terroir—the distinct soil, climate, and people involved in the process. The love of wine is inextricably linked to a respect for the land and what it brings us. Wine is grown, and we meticulously cultivate our vineyards in order to ensure that eventually there is a clear sense of place in the glass.

155

Tim Mondavi, winegrower

Established in 1885, Far Niente prospered until the onset of Prohibition in 1919, when it was abandoned. Sixty years later, Oklahoman Gil Nickel purchased the old winery. During restoration, "Far Niente," which romantically translated from the Italian means "without a care," was discovered carved in stone on the front of the building.

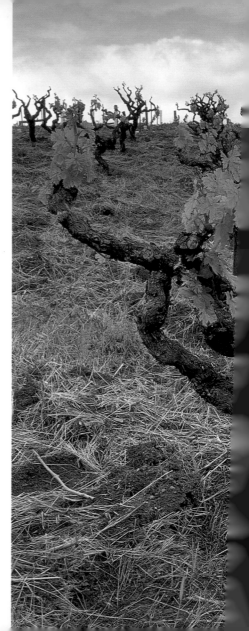

WINE is music

from the vineyard.

Marilyn Clark, vintner

"Old Zin" vines following bud break on the Brandlin Ranch.

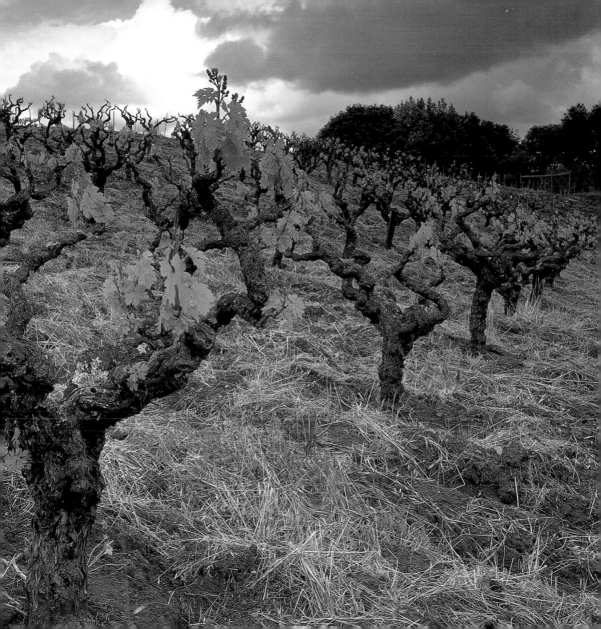

SUMMER'S End:

A crescent moon and a shining star in the luminous dusk above the jagged Mayacamas mountains. "Islam rises," murmured Walter Landor. There was a party going on, of course. There always is, in the Napa Valley.

Herb Caen

Sunset over the Mayacamas Mountains.

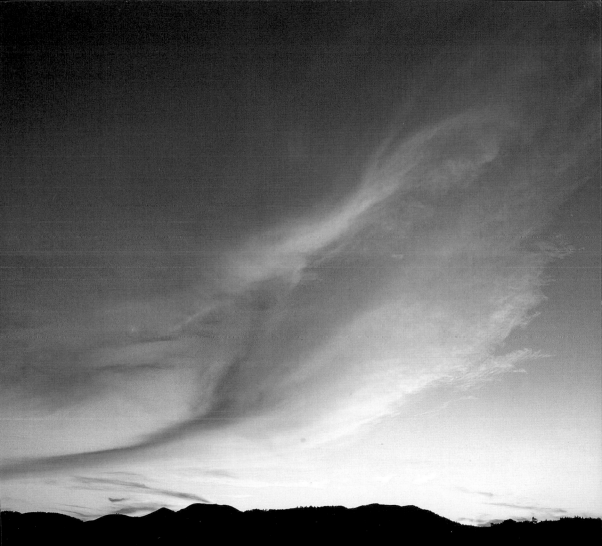

Published in 2004 by Welcome Books
An imprint of Welcome Enterprises, Inc.
6 West 18th Street, New York, NY 10011
Tel: 212-989-3200; Fax: 212-989-3205
e-mail: info@welcomebooks.biz
www.welcomebooks.biz

Publisher: Lena Tabori
Editor: Peter Beren
Art Director: Gregory Wakabayashi
Designer: Naomi Irie
Project Director: Natasha Tabori Fried
Editorial Assistant: Lawrence Chesler

Distributed to the trade in the U.S. and Canada by
Andrews McMeel Distribution Services
Order Department and Customer Service (800) 943-9839
Orders-Only Fax (800) 943-9831

Library of Congress Cataloging-in-Publication Data on file.

Printed in Hong Kong
First Edition
10 9 8 7 6 5 4 3 2 1

LITERARY CREDITS